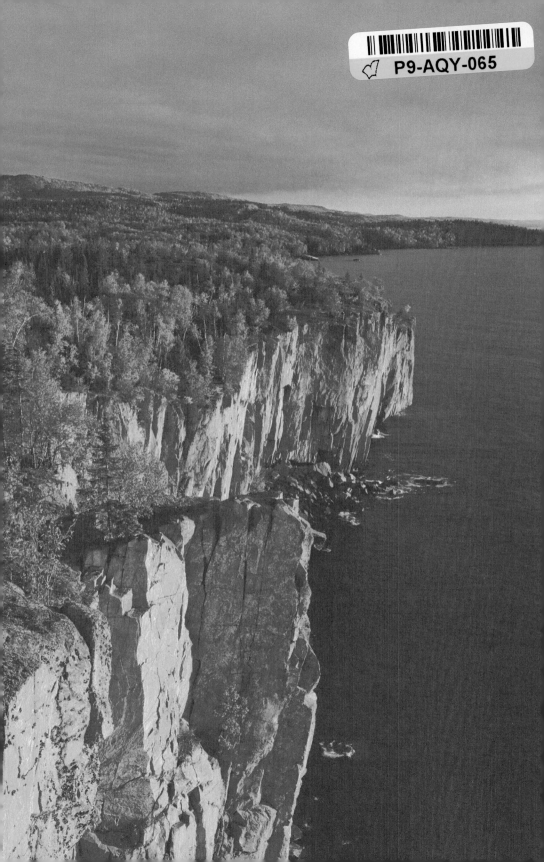

Backroads
of Minnesota

YOUR GUIDE TO SCENIC GETAWAYS & ADVENTURES

TEXT BY Shawn Perich

PHOTOGRAPHY BY Gary Alan Nelson

Voyageur Press

First published in 2002 by MBI Publishing Company and Voyageur Press, an imprint of MBI Publishing Company, 400 First Avenue North, Suite 300, Minneapolis, MN 55401 USA

The information in this book is true and complete to the best of our knowledge. All recommendations are made without any guarantee on the part of the author or Publisher, who also disclaims any liability incurred in connection with the use of this data or specific details.

We recognize, further, that some words, model names, and designations mentioned herein are the property of the trademark holder. We use them for identification purposes only. This is not an official publication.

Voyageur Press titles are also available at discounts in bulk quantity for industrial or sales-promotional use. For details write to Special Sales Manager at MBI Publishing Company, 400 First Avenue North, Suite 300, Minneapolis, MN 55401 USA.

To find out more about our books, visit us online at www.voyageurpress.com.

ISBN 978-0-7603-4066-0

The Library of Congress has cataloged the first softcover edition as follows:

Library of Congress Cataloging-in-Publication Data

Perich, Shawn.
 Backroads of Minnesota : your guide to Minnesota' most scenic backroad adventures / text by Shawn Perich ; photography by Gary Alan Nelson.—1st softcover ed.
 p. cm.—(A pictorial discovery guide)
 Includes bibliographical references and index.
 ISBN 978-0-89658-508-9 (alk. paper)
 1. Minnesota—Tours. 2. Scenic byways—Minnesota—Guidebooks. 3. Automobile travel—Minnesota—Guidebooks. I. Title. II. Series.
 F604.3.P47 2002
 917.7604'54—dc21
 2001057363

Edited by Amy Rost-Holtz and Danielle Ibister
Design Manager: LeAnn Kuhlmann
Layout by Pauline Molinari
Maps designed by Patti Isaacs, Parrot Graphics

Printed in China

FRONTISPIECE: Palisade Head overlooking Lake Superior.
PAGES 2–3: Rolling glacial prairie of the northwestern Leaf Hills.
TITLE: Sioux quartzite on the southwestern prairie in Blue Mounds State Park.
TITLE DETAIL: Hoarfrost on a remnant oak savanna in central Minnesota.
OPPOSITE: Wind generation on the Minnesota prairie.
CONTENTS DETAIL: White pines crowd the rocky shoreline of the St. Croix River.
CONTENTS: Late-blooming flowers enhance an early blush of fall color in the understory of a paper birch forest in Split Rock Lighthouse State Park.

In memory of Mary Casey—SP

To Sisyphus, and all he has

accomplished—GAN

CONTENTS

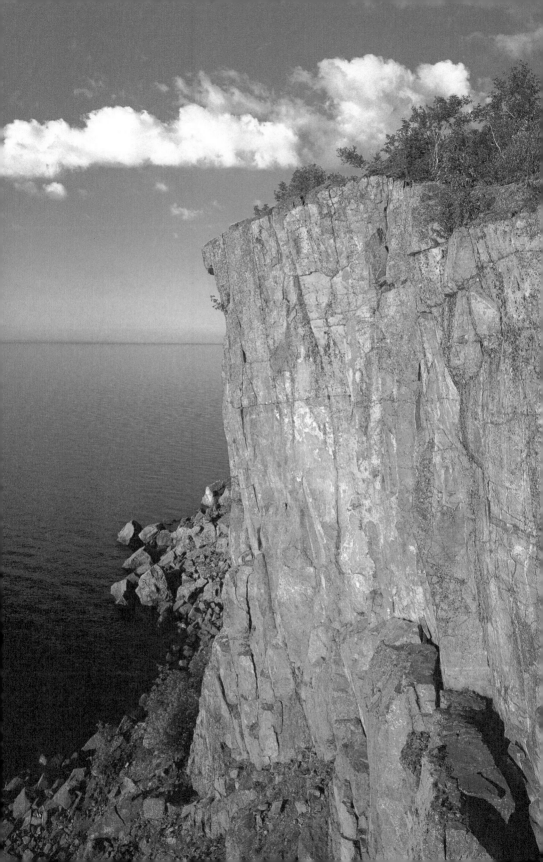

INTRODUCTION

When the road forks, I usually choose the road less traveled. Gary Alan Nelson does the same. Like me, he is endlessly curious to learn what lies around the next bend. This curiosity has compelled both of us to explore the far corners of Minnesota—he as a landscape photographer and me as an outdoor writer. Between the two of us, we've logged thousands of miles on the state's backroads.

A few years ago, Gary and I got together to compare notes on our favorite backroads drives throughout Minnesota. We selected routes that not only displayed the state's scenic beauty, but also its historic

ABOVE: In western Minnesota, the native prairie meets the sky at Upper Sioux Agency State Park.

OPPOSITE: One of the best views of Lake Superior is from the top of Palisade Head, a sheer cliff just east of Silver Bay. The cliff, or palisade, looms two hundred feet over the lake and is composed of columnar jointed rhyolite.

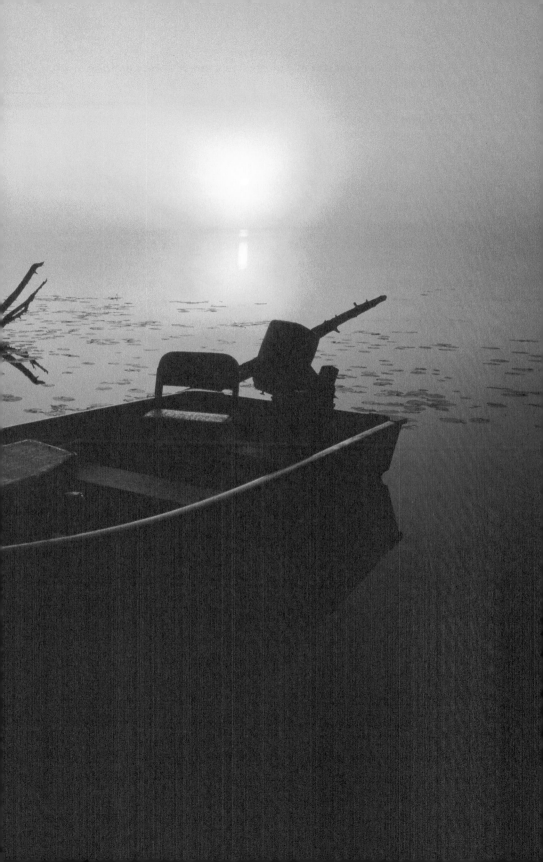

sites, parks, and picturesque small towns. Then, through words and pictures, we shared our routes with readers. The result was the first edition of *Backroads of Minnesota*.

This edition introduces a smaller, more compact format with new photos and updated text. We haven't changed any routes or added new ones because the originals offer a cross section of Minnesota's diverse scenery and history. Best of all, the routes don't have many of the roadside distractions that diminish the scenic value of so many highways and byways passing through developed areas. We prefer quiet rural routes where the people you pass are likely to smile and wave.

We haven't provided exact mileage for the drives, but in this era of Internet mapping and onboard GPS, driving distances are easy enough to find. Most of our drives, with stops, will take you anywhere from a few hours to an entire day to complete. Some routes are worthy of a weekend. On some backroads you'll leave the pavement, but all are accessible with a family sedan. We've dropped little hints about the best times to drive them, such as when wildflowers are blooming in spring or autumn foliage is at its peak.

You can soak up the scenery by driving the backroads, but many points along the way are best explored on foot. Be sure to leave plenty of time to pull over and explore parks, hiking trails, main streets, and more. With the exception of places like the Boundary Waters Canoe Area Wilderness and Voyageurs National Park, most points of interest we've chosen can be investigated by someone wearing walking shoes.

You might want to bring a canoe, because many of the backroads lead to water. Minnesota is a headwaters state; streams originating here flow to Hudson Bay, the Gulf of Mexico, and the Atlantic Ocean. Our backroads follow the state's great rivers, such as the Minnesota, St. Croix, and Mississippi. The drives pass along the shores of such lakes as Leech, Winnibigoshish, Mille Lacs, and Lake of the Woods. And we've included the drive along the North Shore of the great inland sea—Lake Superior.

Dozens of summertime events commemorate Minnesota's farming heritage.

You may be surprised at how many state parks, nature preserves, and wildlife areas are mentioned in this book. Minnesota has a rich collection of public natural areas. We've mapped out our backroad routes so you can visit these places and pointed out what you may see in terms of wildlife and native vegetation. From Minnesota's backroads, you can see gray wolves, moose, trumpeter swans, bald eagles, and black bears. You can also find wild vegetation ranging from old-growth forests to native prairie, from cathedral-like pine groves to cactus-studded grasslands.

Another surprise is the state's colorful history. Hundreds, perhaps, thousands of years ago, native people etched and painted figures in rock outcroppings. Some of the New World's first European adventurers explored the landscape that became Minnesota. Later came the fur trade, Indian battles, sod busting, riverboats, and a famous failed bank robbery. Many Minnesota communities were established between 1850 and 1880. Individual structures and historic districts dating to that frontier era are found throughout the state. The backroads will lead you to remnants of this vivid past.

Which routes are our favorites? Gary is partial to the Glacial Ridge Trail and Otter Tail County in west-central Minnesota. Even though I'm partial to my home, the North Shore, I was struck by the vastness of the prairie in the far southwest at Pipestone National Monument and Blue Mounds State Park. But every backroad drive is a pathway to scenic, special places.

This book is intended as a celebration of Minnesota's backroad beauty, rather than a strict tour guide. We've provided driving directions for every route, but when in doubt on the road, consult a map or seek local advice. Every backroad in the book is shown in the DeLorme's *Minnesota Atlas & Gazetteer*.

Hit the road and get out there. In this great state, you'll never run out of new backroads to explore.

—Shawn Perich, 2011

BELOW: In March, Lake Superior piles plates of ice along its rocky shore.

A weathered barn in Pipestone County has stood the test of time.

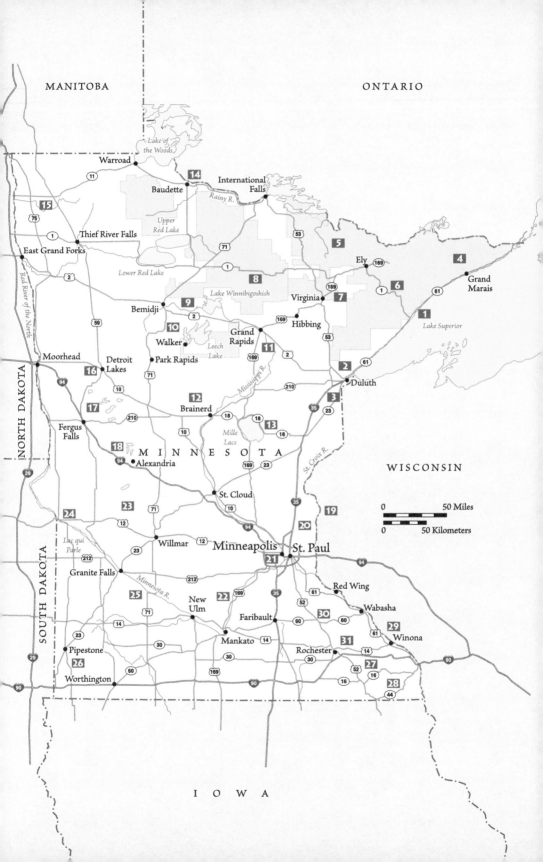

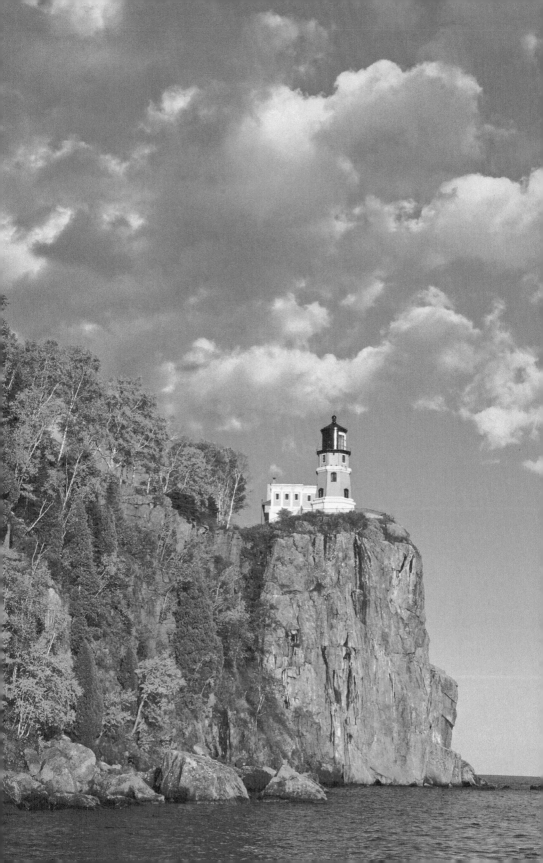

PART I

The Northeast

Land of the Voyageurs

ourist promoters of Minnesota's Arrowhead region once had an audacious slogan: Welcome to the Real Minnesota. With it, they staked a bold claim to Minnesota's image as a place with tall pines and clear, blue water. Of course, the good people of Brainerd, Bemidji, or Walker may dispute the Arrowhead's boast. After all, there is plenty of the Real Minnesota to go around. Nevertheless, northeastern Minnesota does contain such natural jewels as the Boundary Waters Canoe Area Wilderness (BWCAW), Voyageurs National Park, and the North Shore of Lake Superior. Wild waters and forests set this lightly populated region apart.

OPPOSITE: Split Rock Lighthouse, a state historic site, arguably is the most popular North Shore tourist destination. The lighthouse was built by the federal government in 1910 and remained in operation until 1969, when radar rendered it obsolete.

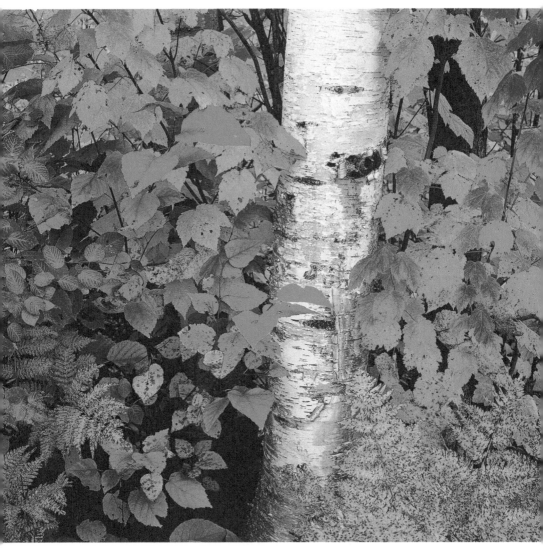

A paper birch stands in bold relief to a palette of fall colors in the Superior National Forest. One of two national forests in Minnesota, Superior encompasses over three million acres and contains more than two thousand lakes. Cars can easily drive into the forest by a number of gravel logging roads, and hikers can enter it via the Superior Hiking Trail.

The farther north you drive in the Arrowhead, the more likely you are to encounter moose rather than humans. As you may expect, this is a rawboned place, populated by a few very independent people. Most folks who call the Arrowhead home have no desire to live anywhere else.

The Canadian Shield, a glacier-scoured mass of volcanic rock, extends southward from Ontario into northeastern Minnesota. The geology and northern climate, further chilled by Lake Superior, allow the boreal forest to protrude into the Arrowhead. Too cold and rocky for farming, the Arrowhead's economy is driven by the three T's—taconite, timber, and tourism. Taconite is an iron-bearing rock that's refined into high-grade pellets at mines and processing plants across the Iron Range. Timber supplies the raw material for paper and other wood products manufactured in the region. Tourism serves travelers drawn to the Arrowhead's many outdoor attractions.

Much of the Arrowhead's landscape is untamed, and a tremendous amount of it is public land, including the three-million-acre Superior National Forest, numerous state forests, county forests, state parks, and other public holdings. You'll find lots of room to roam and minimal development in the northwoods. Expect to encounter deer and black bears along the backroads. Moose are common in some locales. A chance timber wolf sighting is always possible. Good fishing is never far away. Throughout the Arrowhead the preferred mode of water travel is by canoe. You are never far from a wild place to paddle.

Lake Superior, the cold freshwater sea, is like no other lake; nothing in the Upper Midwest compares with the rugged beauty of Lake Superior's rocky coast. Lonely roads such as the Echo Trail, Minnesota Highway 1, and the Gunflint Trail penetrate the remote northern forest. Along the Canadian border a maze of wilderness lakes is protected by the Boundary Waters Canoe Area Wilderness and Voyageurs National Park. In contrast is the Iron Range, where iron ore has been mined for a century. Duluth, at the Head of the Lakes, is the nation's most inland seaport, opened to ocean-going ships when the St. Lawrence Seaway was completed in 1959.

When you roam off the pavement, be sure to have a detailed local map. There are a maze of gravel forest roads in the north, many of which are negotiable with an average automobile. All lead to interesting places. Using a map will get you into the woods and out again.

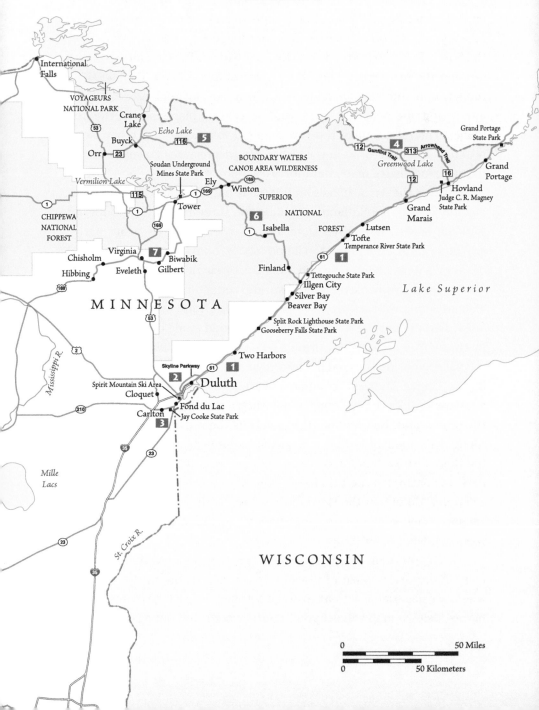

The North Shore Drive

HIGHWAY 61

||

Directions Follow Minnesota Highway 61 from Duluth to the Canadian border.

||

Bobby Zimmerman made a wrong turn in Duluth.

Years ago, young Bobby Z. got itchy feet and set off for the wide world beyond northeastern Minnesota's Iron Range. He turned south on Minnesota Highway 61 when he hit Duluth, changed his name to Bob Dylan and . . . well, you've probably heard the song.

Unless you have a latent desire to play bad harmonica and sing through your nose, don't follow Bobby's route from Duluth. Instead head north on Highway 61 and discover the North Shore.

Highway 61 follows Lake Superior's rugged coast for 150 miles from Duluth to the Ontario border. It's a wild route with gorgeous scenery, good fishing, and accommodations ranging from wilderness campsites to surfside condos. You can hike, ride a mountain bike, browse art galleries, paddle a canoe, eat fresh fish, wander historic sites, meet sled-dog mushers, hear good music, attend plays, ogle ore freighters, watch wildlife, hug a tree, have a hot soak, or just listen to waves crashing on the beach.

Two must-see stops on any Highway 61 adventure are Gooseberry Falls and Split Rock Lighthouse State Parks. The Gooseberry River waterfalls are easily viewed from walking paths in the park. Split Rock Lighthouse, poised on the edge of a spectacular cliff, has been the North Shore's star attraction since the highway was completed in 1924. Sights worth seeing at other state parks include the Shovel Point Trail in Tettegouche, the beach at Temperance River, the cascades at Cascade, the Devil's Kettle at Judge C. R. Magney, and the tremendous waterfall at Grand Portage State Park.

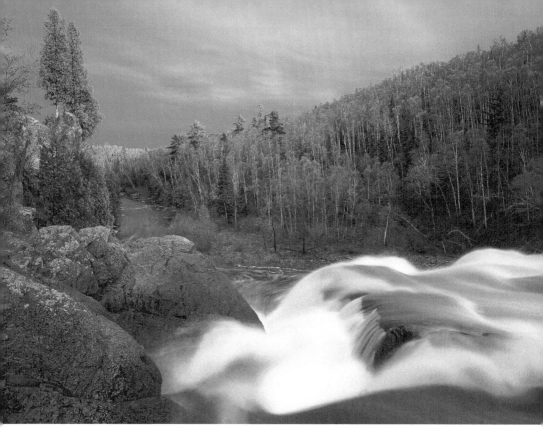

The Baptism River's High Falls in Tettegouche State Park is officially the tallest waterfall in the state.

The North Shore is the eastern gateway to the Superior National Forest and Boundary Waters Canoe Area Wilderness. Four roads leading northward from Highway 61—the Sawbill, Caribou, Gunflint, and Arrowhead Trails—dead-end at the edge of the canoe country. Along these forest roads are dozens of wild lakes, national forest campgrounds, and scattered resorts.

The North Shore's permanent population numbers less than twenty thousand, but annually swells with "summer people." Tiny towns are community hubs. Twenty miles from Duluth is Two Harbors, where lake freighters load taconite mined on the Iron Range. Walk along the breakwall to see the boats and the ore docks.

The next communities are Beaver Bay, a former fishing village, and Silver Bay, a planned community built in 1951 for workers at a taconite processing plant. In the 1970s, a controversial court ruling forced the

FALL COLOR ON
THE NORTH SHORE

THE NORTH SHORE has a surprisingly long fall color season, due to changes in both elevation and vegetation. A little knowledge can go a long way to help you find the best colors during your visit.

The most striking display occurs in mid to late September, when maple ridges blaze scarlet. The maples are primarily found along the high hills a few miles west of Lake Superior. One of the best places to see these trees is north of Schroeder and Tofte, where Forest Road 166 is a popular color drive. At a place called Heartbreak Hill, the road passes beneath a canopy of maples—their brilliant fall foliage is breathtaking.

If you continue farther inland, say by driving north on the Sawbill Trail, you'll enter a forest where the primary hardwoods are aspen and birch. Their foliage turns yellow in early October and contrasts with the green conifers.

Believe it or not, you can also find fall beauty in clear-cut areas splashed with color from saplings and other vegetation. Another awesome color drive is Minnesota Highway 1 north from Minnesota Highway 61 to Finland, looping back to the North Shore on County Road 6. The bold, rocky ridges along this route may remind you of New England.

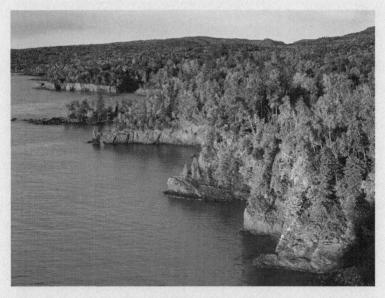

Minnesota's only mountains, the Sawtooth Range, form the rocky spine of the North Shore, rising one thousand feet or more above Lake Superior.

The Spirit Little Cedar, a four-hundred-year-old cedar tree on Grand Portage's Hat Point, is sacred to the Ojibwe. A white artist renamed the cedar the "Witch Tree" in the early twentieth century.

plant to stop discharging asbestos-laden tailings into Lake Superior. The plant now dumps the tailings at an inland site.

Tofte and Lutsen boast the Superior National champion golf course and the Lutsen Mountains ski area, as well as condos and motels.

Farther north is the artsy, lakeside village of Grand Marais. Set aside time for shopping and strolling in Grand Marais' shops and galleries. At a community art center, you can see locally produced plays and musical performances. Artist's Point, a natural, ledge-rock breakwall at the harbor, is one of the best places on the North Shore to get up close and personal with Lake Superior.

Near the Canadian border is the Ojibwe community and former fur-trading post of Grand Portage. Be sure to visit the interpretative center at the Grand Portage National Monument to see its extensive collection of fur trade and Ojibwe artifacts. Arrange a tour locally to visit the Witch Tree, a twisted, four-hundred-year-old cedar growing from shoreline rocks. Ojibwe and French canoe parties once left tobacco offerings at the tree for safe passage on Lake Superior.

The five-mile stretch from Grand Portage to the Canadian border is the most scenic portion of Highway 61. From Mount Josephine you

can see the Susie Islands, as well as Isle Royale, which lies twenty miles offshore. Isle Royale excursions are available. At the border is Grand Portage State Park, where the Pigeon River plunges over High Falls.

If you want to take a hike, explore portions of the one-hundred-mile-long Superior Hiking Trail. Expect strenuous walking, with steep hills and muddy spots, on a well-marked path that leads through lush forests to hidden waterfalls and sweeping vistas. Other area hiking trails lead to places such as Eagle Mountain, Minnesota's highest point at 2,301 feet.

Autumn color along the Shore is spectacular. Superior "storm watchers" wait for nor'easter gales in October and November to hurl angry surf at the craggy shores, sometimes flooding downtown Grand Marais. Inland, the first snows occur in October. Freeze-up and deer season come in November. The ski hills open on Thanksgiving, and the cross-country skiers and snowmobilers arrive in December. Dozens of dog mushers live here, especially east of Grand Marais.

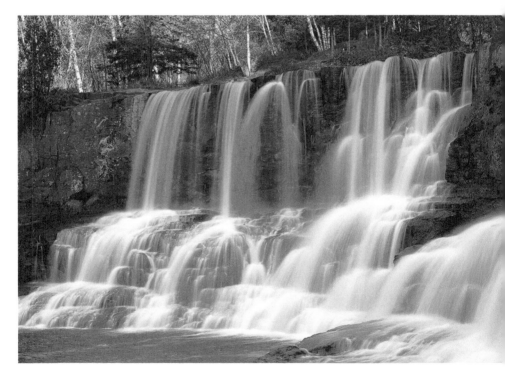

Water tumbles over the Lower Falls on the Gooseberry River, one of several cascades in Gooseberry Falls State Park.

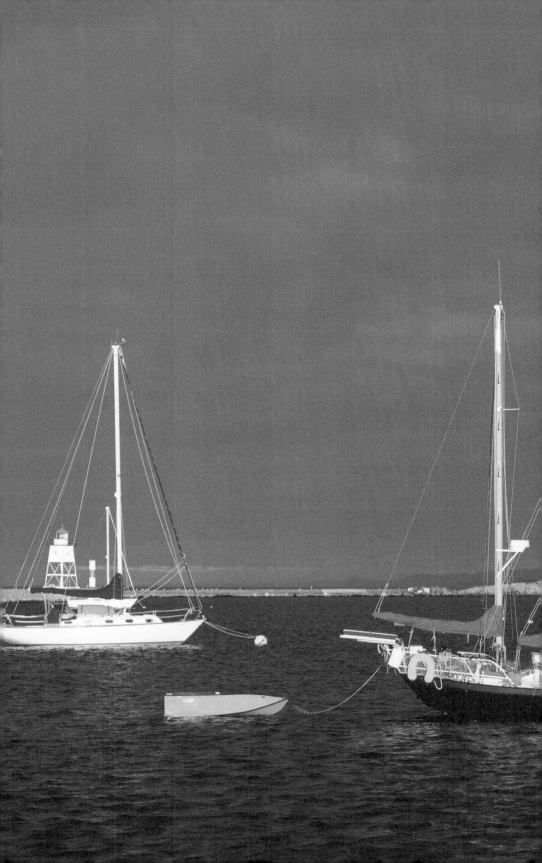

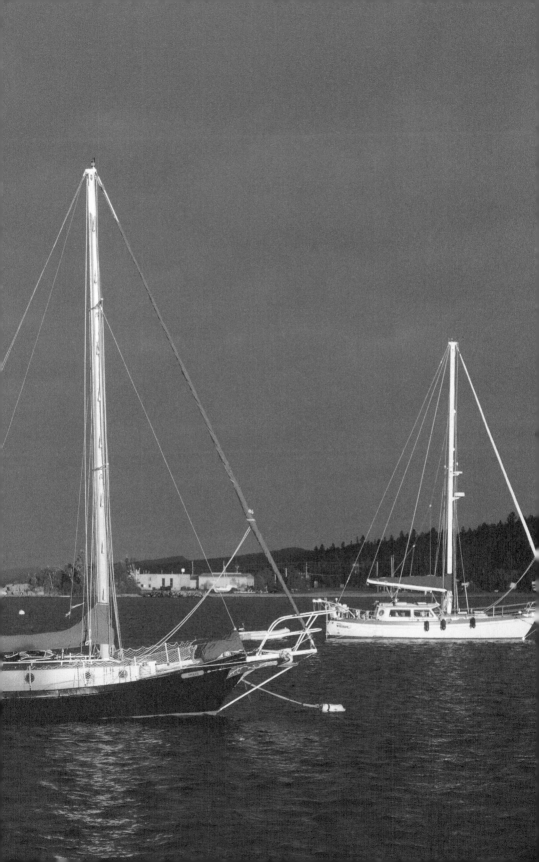

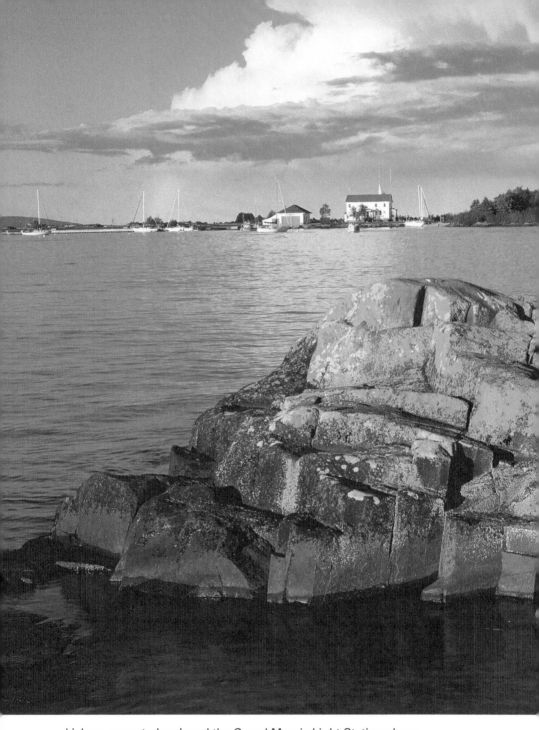

Lichen-encrusted rock and the Grand Marais Light Station along
Lake Superior.

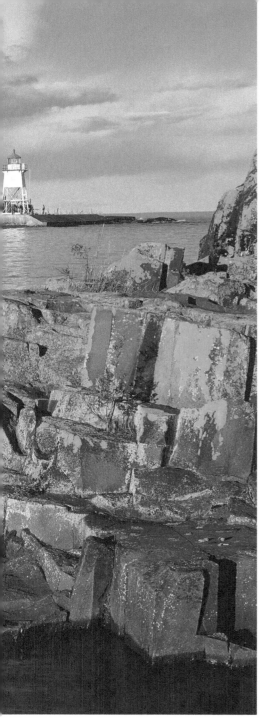

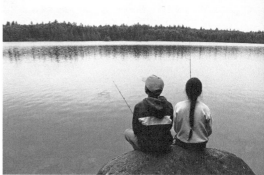

PAGES 30-31: The centerpiece of Grand Marais is its harbor. Once a port for commercial fishing and rafting logs, the harbor now is used for recreational activities.

Give kids a couple of fishing rods and just add water.

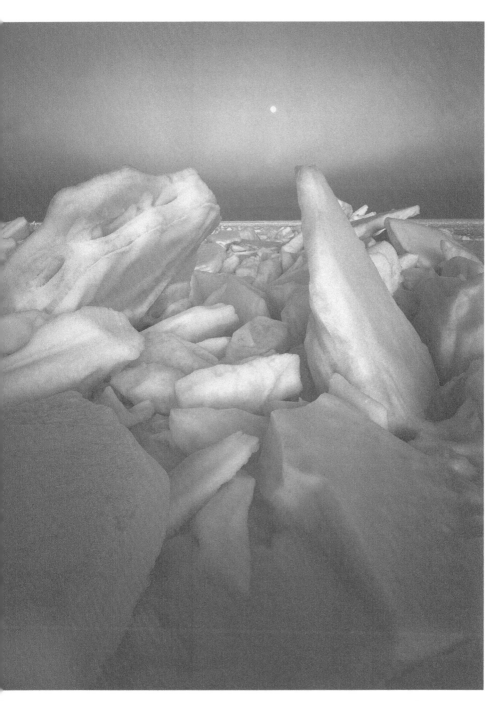

Pack ice piles along Lake Superior's shores in late winter, typically the only time ice forms on the lake.

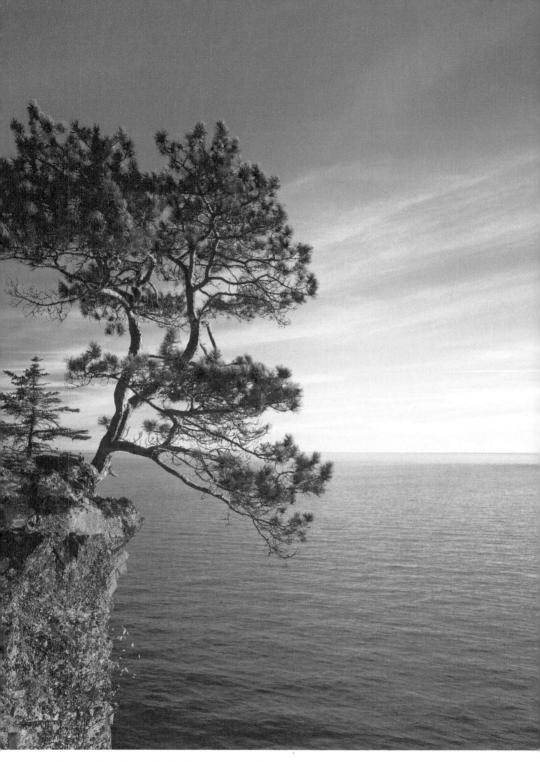

Exposed to Superior's elements, a red pine clings to a North Shore bluff.

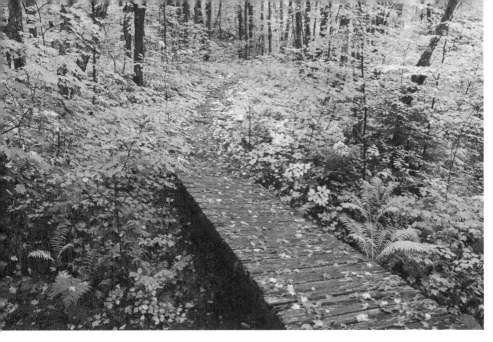

Part of the Superior Hiking Trail, a boardwalk winds through a lowland forest.

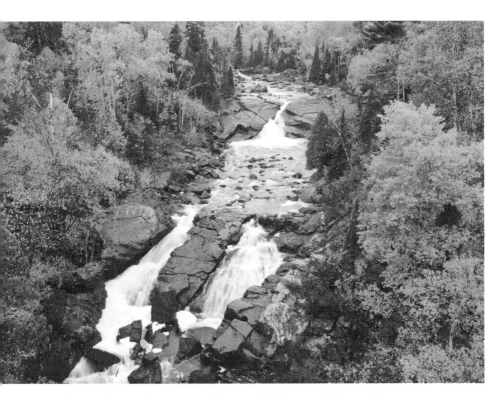

These Beaver River waterfalls are visible from Highway 61.

ROUTE **2**

Looking Down on the City

DULUTH'S SKYLINE PARKWAY

Directions Skyline Parkway crosses Interstate 35 at the Spirit Mountain exit. If you go west from here, the road becomes gravel beyond the Spirit Mountain ski area. Going east, follow the signs all the way to Lester River at the beginning of the North Shore Drive.

If you really want to see Duluth, follow the Skyline Parkway. Unlike the congested waterfront or the big shopping mall over the hill, the parkway shows off the city's wild side with outstanding views of the Duluth-Superior Harbor and Lake Superior. Along most of its route, the drive follows a hillside terrace—the ancient shoreline of a glacial lake—about six hundred feet above the lake and harbor. Skyline Parkway is marked with signs.

The parkway opened in 1891, and the first five-mile stretch was soon popular with sightseers in horse-drawn carriages. The route was eventually completed nearly fifty years later when the parkway extended over thirty miles, from Jay Cooke State Park in the west to the Seven Bridges Road on the Lester River in the east. Over the years, the western terminus fell into disrepair. West of the Spirit Mountain ski area, the parkway exists as a gravel road. Passing through an old-growth, maple-basswood forest, this western segment, winding though Snively and Magney city parks, is an excellent place to find forest wildflowers such as trillium and bloodroot. (The stretch leading into Jay Cooke State Park from Beck's Road is closed.)

If you prefer pavement, follow Skyline Drive eastward from Interstate 35 at Thompson Hill to the Seven Bridges Road. Most of the route is narrow and winding—with a view. Frequent roadside pull-offs allow you to stop and admire the scenery. Along the way you'll notice numerous old retaining walls made of locally quarried stone. About midway along

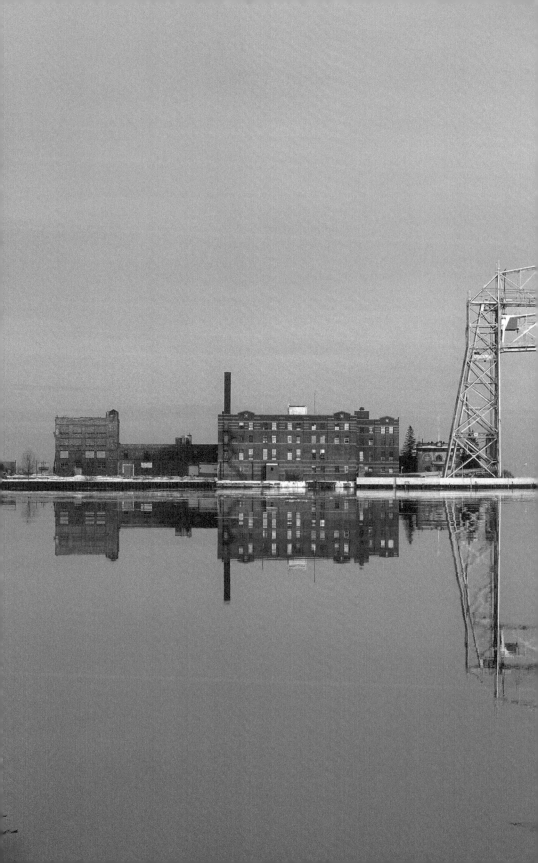

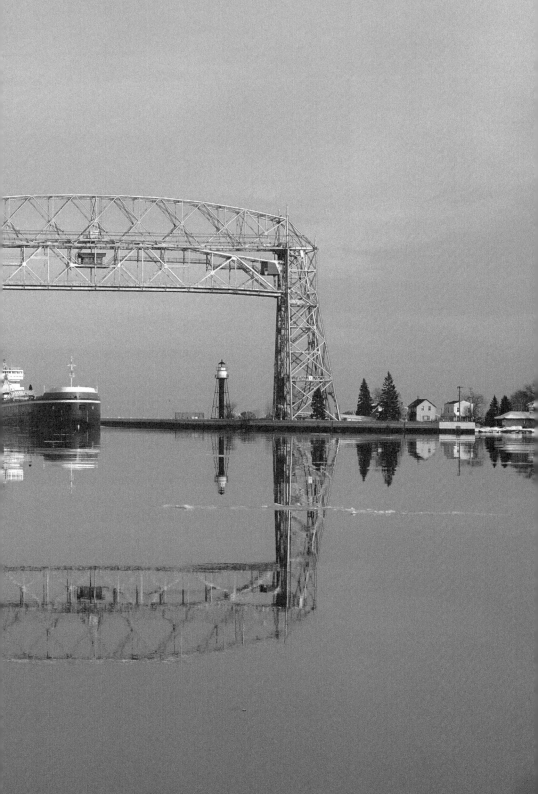

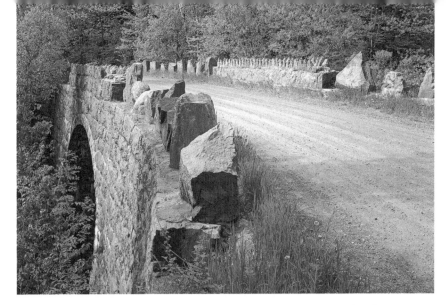

Numerous stone bridges built by public works crews during the Great Depression span the creeks along Skyline Parkway and the Seven Bridges Road.

PAGES 38-39: The center span of Duluth's Aerial Lift Bridge rises to allow ore carriers and ocean freighters to enter the city's harbor.

PAGES 42-43: Located near the eastern terminus of Skyline Drive, the city park at Brighton Beach is a picnic ground "air-conditioned" by Lake Superior's cool breezes.

the drive, a short road leads to a stone structure called Enger Tower. Almost medieval in appearance, the observation tower was built in memory of Bert Enger, who donated the land it sits on to the city when he died in 1931. The tower is the highest point overlooking Duluth and offers striking views of the harbor and the famous Aerial Lift Bridge. Its base is 1,185 feet above sea level or 583 feet above Lake Superior. The light on top of the 75-foot tower can be seen for over thirty miles. Nearby are a public golf course and the Twin Ponds, a popular city swimming area.

Farther east, the parkway passes through staid residential neighborhoods and the university district. The route is well marked with signs. Keep heading east to reach the famous Hawk Ridge, where birders gather every September to observe one of North America's largest migrations of hawks and eagles. On peak days, thousands of hawks, soaring and circling in flocks called kettles, pass overhead.

Following the high ridge that rises from Lake Superior's North Shore, they funnel through this location. Some birds may be at eye level, but many fly higher. Bring binoculars.

The stone bridges on the winding Seven Bridges Road date to another era. Beneath the bridges runs Amity Creek, a tributary of the Lester River. Popular walking and ski trails course through the Seven Bridges area. You can follow the road all the way to Highway 61, where it meets the North Shore Drive. Less than a mile east of this intersection a short road leads to Brighton Beach (or Kitchi Gammi Park), a large city park on the shores of Lake Superior. There you can have a picnic, toss stones in the water, or just enjoy the beauty of the Great Lake.

While in Duluth, other sights worth seeing include the Aerial Lift Bridge; the Glensheen mansion; "the Depot" (the nickname for the St. Louis County Heritage and Arts Center), which includes the Lake Superior Railroad Museum; and Park Point (also known as Minnesota Point), a long sand spit that separates Lake Superior from the Duluth Harbor.

Duluth is called the "air-conditioned city" because the cold water of Lake Superior influences the local climate. In summer, air temperatures are cooler by the lake—often by ten degrees or more— than temperatures a few miles inland. As you climb Duluth's hill, the changing point for temperature often seems to be at the elevation of Skyline Parkway. In summer, a dense layer of fog may form here when warm inland air meets the cold air mass enveloping the lake. When Lake Superior isn't frozen in the winter, the climatic situation is reversed. Temperatures near the lake are warmer than inland temps. Sometimes on wet, early winter days, Skyline Parkway marks the point where rain turns to snow as you ascend from lake level.

Lake Superior's cool climate affects not only the weather, but also the natural vegetation growing in Duluth. The lake's influence is especially noticeable along Skyline Parkway. On the western end, near Spirit Mountain, the hardwood forest is indicative of a somewhat warmer microclimate. Scrubby aspen stands, which regenerated after the devastating Cloquet fire in 1918, grow along much of the parkway's length. On the eastern side of Duluth, especially along the creek valleys, you'll find spruce and pine. This southern extremity of the boreal forest takes advantage of the cool lake effect.

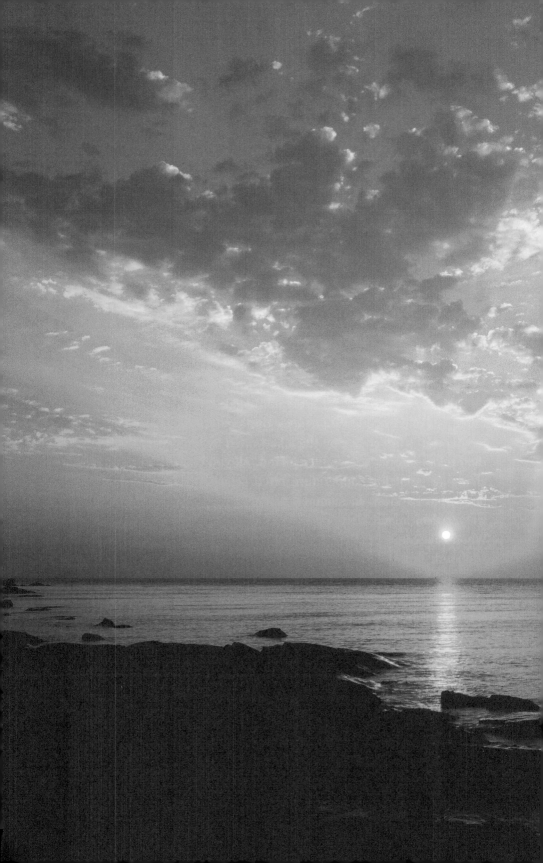

ROUTE (3)

Where the River Roars

HIGHWAY 210 THROUGH JAY COOKE STATE PARK

Directions Minnesota Highway 210 crosses Interstate 35 south of Cloquet. From there, follow the highway east through Jay Cooke State Park.

Downstream from Carlton, the St. Louis River descends through a rocky gorge in a tumult of white water. Historically, canoe parties who used the river as a westward highway were forced to portage several miles through what is now Jay Cooke State Park to get around the long series of rapids. It wasn't a cakewalk—the country is surprisingly rugged, with steep hills bordering the river. In spring, the river is a foaming rage of whitewater.

Although river rafters and kayakers often take to the rapids upstream from Carlton, the stretch through Jay Cooke is rarely traversed. You can walk across the river on the park's famous Swinging Bridge, where the currents are forced through a narrow chasm. The surging river has been harnessed for power generation. Minnesota Highway 210 crosses the St. Louis immediately downstream from the Thomson Dam. From there the water follows a rough-and-tumble course through the rocks until it is stilled in the reservoir formed by the Fond du Lac Dam.

Jay Cooke has impressive stone structures that date to the era of the Civilian Conservation Corps, which had a camp in the park. Within the state park is a small Ojibwe cemetery, which has tombstones dating to the 1800s.

OPPOSITE: The St. Louis River snarls and rumbles over precipices as it flows through Jay Cooke State Park.

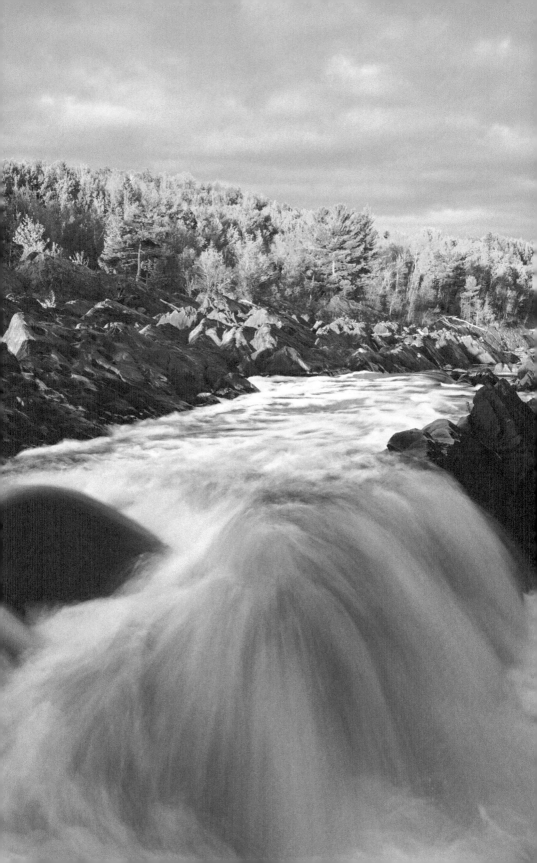

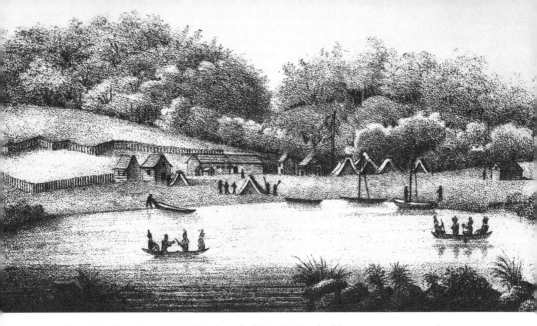

Fond du Lac, located at the head of the St. Louis River estuary, was the site of an American Fur Company trading post in 1827. *Courtesy of the Minnesota Historical Society*

You can camp, picnic, and hike in Jay Cooke, but the park's real allure is driving Highway 210. The road climbs over and around remarkable hills. In terms of vegetation, this is where north meets south. The forests are a mixture of oaks, maples, and elms, as well as aspen, birch, balsam, and spruce. In spring, the forest floor is a carpet of wildflowers. During winter, look for deer bedded on the south-facing slopes. A stunning view of the St. Louis River valley is available from the roadside pull-off at Oldenburg Point.

The tiny community of Fond du Lac, Duluth's westernmost neighborhood, is one of the oldest settlements in Minnesota. Located where the fast-flowing St. Louis River enters its lake-like estuary, Fond du Lac was a natural location for a village in the era when Native Americans, fur traders, and missionaries traveled by canoe. The settlement marked the downstream terminus of the long portage.

Perhaps the most colorful figure to pass through Fond du Lac during the fur-trade era was General Joseph Dickson. He arrived in Fond du Lac in late October 1836 on a passenger vessel from Sault Ste. Marie. With him were five lieutenants, twenty-seven enlisted men, and one Polish refugee. The general told missionary Reverend Edmund Ely that he was bound for the Rocky Mountains, where he planned to

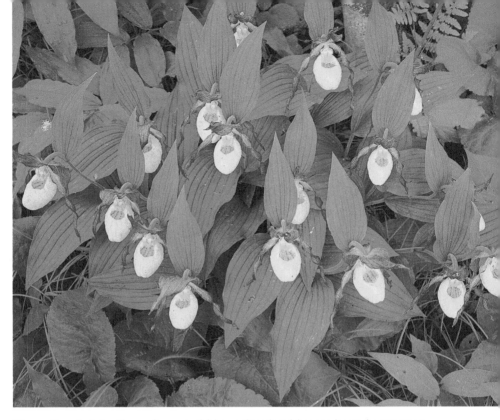

The yellow lady's slipper is an orchid species that blooms in early summer at Jay Cooke State Park.

train and build his army. From there he planned to march to Mexico City, conquer it, then declare himself Montezuma the Second. He also planned to rally the Indians and lead them on a conquest of California. Alas, the good general was California dreaming—at the onset of a Minnesota winter. He left Fond du Lac, headed west, and wasn't heard from again.

The level, riverside ground in Fond du Lac's Chambers Grove Park was likely the site of a frontier village. Many decades ago, the park contained a recreated stockade and other log structures and was a popular place for Duluthians to go on Sunday outings. A side-wheeler called the *Montauk* made excursion trips up the river from the Duluth Harbor.

From a wayside rest on Minnesota Highway 23 about two miles south of Fond du Lac, you can see Jay Cooke's southern interior. The grand sweep of landscape visible from here is roadless, and, surprisingly, just minutes away from the Duluth metropolitan area.

At the Tip of the Arrowhead

THE GUNFLINT AND ARROWHEAD TRAILS

Directions From Grand Marais, follow the Gunflint Trail (County Road 12) sixty miles to its end, then back track to the Greenwood Lake Road and turn east. From the Greenwood Lake Road, turn north onto Forest Road 313, which intersects with the Arrowhead Trail (County Road 16). Take the Arrowhead Trail back to Hovland and Highway 61.

For many northwoods aficionados, adventure begins in Grand Marais, where the Gunflint Trail starts its steep climb up the Sawtooth Mountains from the Lake Superior coast. Penetrating sixty-plus miles into the Superior National Forest and dead-ending just short of the Canadian border at Saganaga Lake, the Gunflint was once a walking path and tote trail. The road is now paved along its entire length. For a popular tourist destination—indeed, one of international stature—the Gunflint remains remarkably wild and uncluttered with development. Local resorts cater to a clientele that travels here for high-quality outdoor experiences such as canoeing and cross-country skiing. Up here, you might say, northwoods ambience is an industry.

The scenery is dramatic. The road passes through a rugged range of hills, crossing wild rivers like the south and north branches of the Brule. Tall pines, dark and silent, cloak the rocky hills. Sheer black cliffs, called palisades, plunge into crystalline lakes with magic names—Clearwater, Hungry Jack, West Bearskin, Loon, Gunflint. It is these lakes, tucked into folds of the hills, their shorelines shrouded with ancient cedars, that make this place like nowhere else.

There is much here to explore. If you have a canoe, so much the better, because you can most truly appreciate this place with a paddle

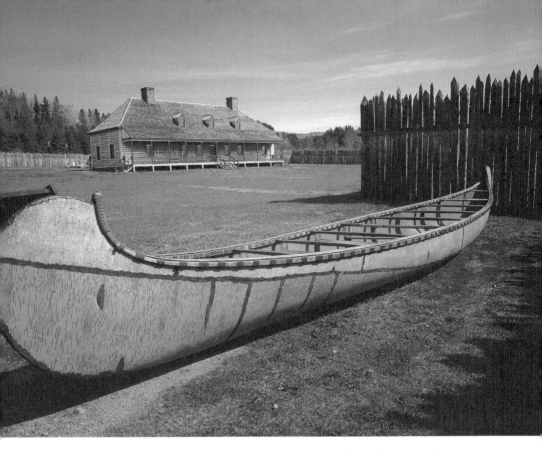

Canoes, such as this one in front of the Great Hall at Grand Portage National Monument, were used to transport furs across the Great Lakes from Grand Portage to Montreal, Quebec. A round trip required an entire summer.

in hand. (The northern portion of the Gunflint Trail divides the eastern portion of the Boundary Waters. A number of wilderness access points are located along the side roads.) However, intrepid windshield tourists can find the spirit of the Gunflint, too.

A short walk to the top of Honeymoon Bluff, off the Clearwater Road (County Road 66), affords a stunning view of Hungry Jack Lake and the wild country that lies beyond it. Near Gunflint Lake, a short walking trail off the Gunflint leads to Magnetic Rock. Bring a compass and you'll understand how it got its name. Rocks, magnetic and otherwise, once drew prospectors to the Gunflint frontier. Although there are nearby iron mines in Minnesota, silver mines in Canada, and copper mines on Isle Royale, no one ever struck it rich with a mine on the Gunflint. Good thing.

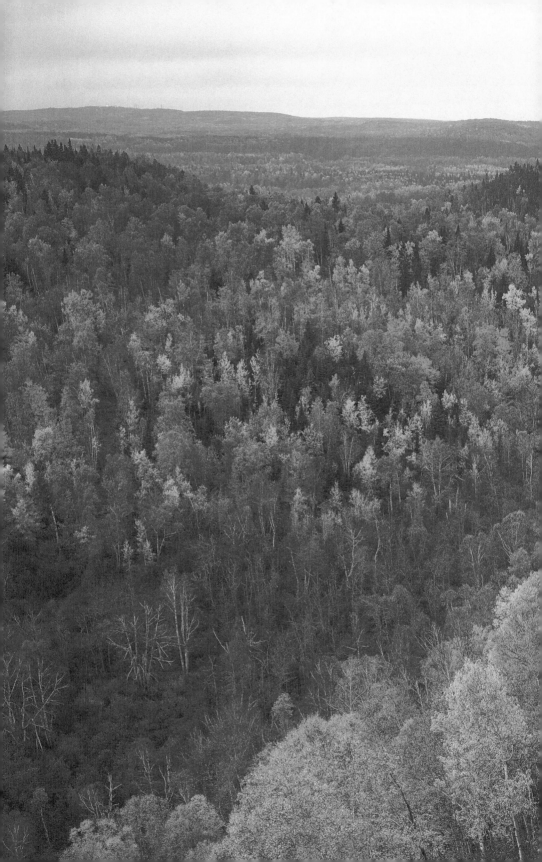

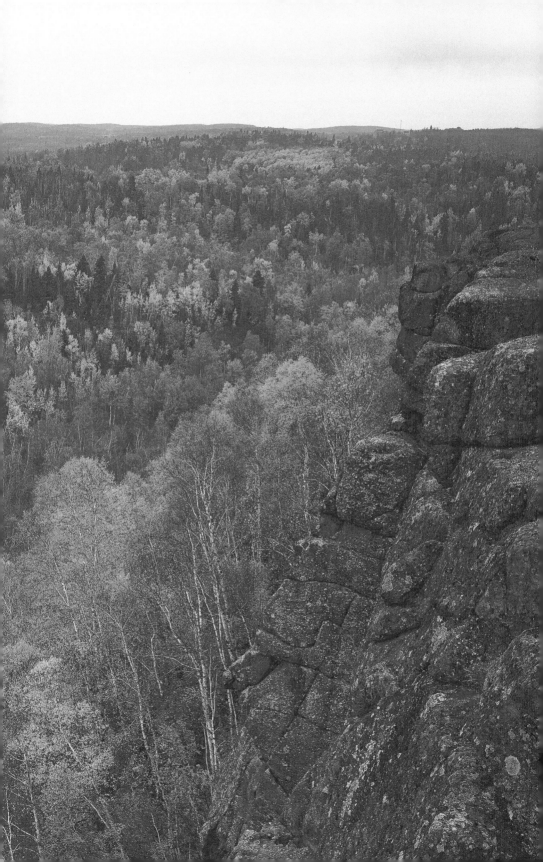

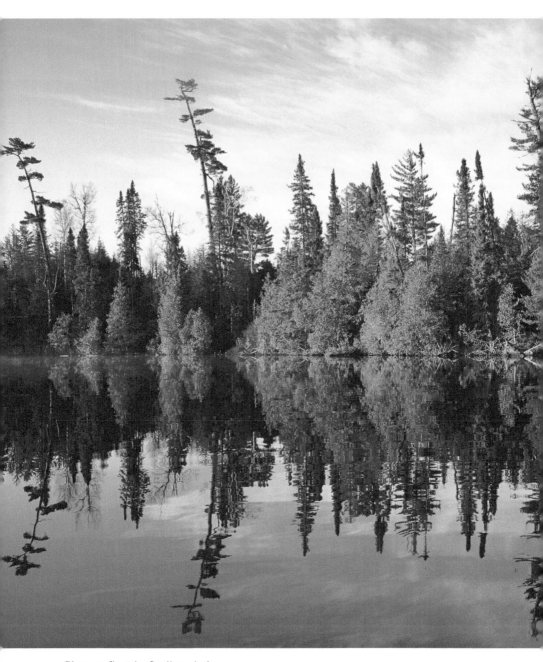

Pines reflect in Caribou Lake.

PAGES 50-51: An unbroken, mixed boreal forest covers the rugged, rocky ridges of the Sawtooth Mountains.

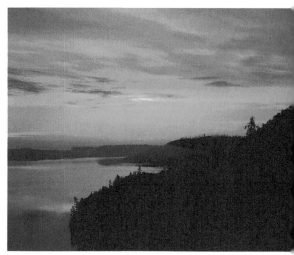

Rose Lake, on the Canadian border, was once on the voyageurs' inland canoe route. The famous Stairway Portage connects Rose and Duncan Lakes.

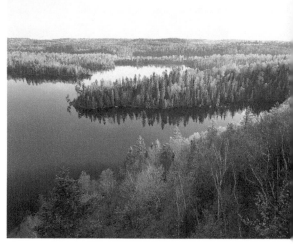

A short hiking trail leads to the top of Honeymoon Bluff, overlooking Hungry Jack Lake, just off of the Gunflint Trail.

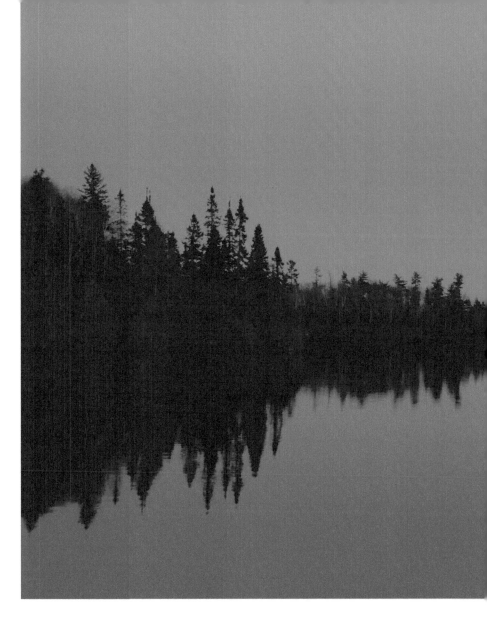

If you'd like to look for wildlife and don't mind raising some dust, head east from the Gunflint Trail on the gravel forest road leading to Greenwood Lake. At Assinika Creek, Forest Road 313 heads north and east to the Arrowhead Trail. In the clear cuts and swampy meadows along this route, you may see moose and black bear, especially in early morning or evening. Don't worry about getting lost, Forest Road 313 is as wide as a highway and marked with signs.

Eventually, you'll reach the Arrowhead Trail, a gravel road that

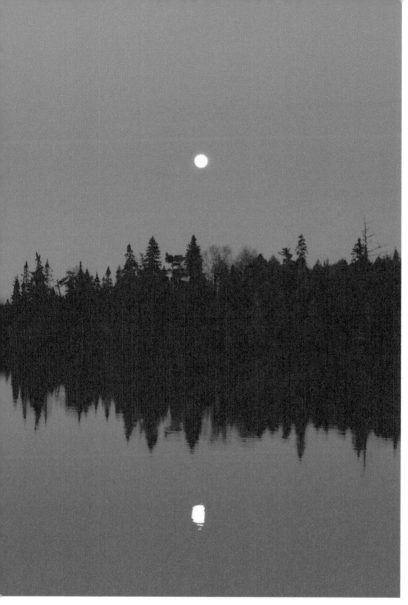

In the summer, twilight lingers in the north country as the moon rises.

dead-ends on the edge of the wilderness at Little John Lake. There is an overlook just south of the 313 intersection that offers a tremendous view of a wide valley. Some of the distant hills and palisades you can see are across the border in Canada.

The vast Swamp River Marsh, east of the Arrowhead Trail, is accessible only with a canoe or small boat, but is one of the best places to view northwoods wildlife, including eagles, moose, otters, and waterfowl.

An Echo of the Wilderness

ECHO TRAIL TO CRANE LAKE AND VOYAGEURS NATIONAL PARK

Directions The Echo Trail (County Road 116) runs from Ely to meet County Road 24 just north of Buyck, near Echo Lake. From there, you can go north on County 24 to Crane Lake. Or you can take County 24 south to Buyck, then go south on County Road 23 to Orr.

When you head for the Echo Trail, bring a bucket—the blueberries up here are plump and sweet. Wear sturdy footgear, too—you may take a hike. While you're at it, pack a tent, because there are plenty of places to pitch it. And don't forget the canoe.

The Echo Trail, County Road 116, passes through the wilderness between Ely and Buyck. The trail is mostly gravel but is easily passable with an automobile. Just be prepared for the outback: Start out with a full tank of gasoline and carry food, water, warm jackets, and rain gear. Plan to spend several hours making the drive (with stops) from Ely to Crane Lake and then out to civilization and U.S. Highway 53 at Orr.

Hardcore hikers will find some of the Boundary Waters' best hiking trails originate along this backroad. The Echo Trail skirts the western edge of the BWCAW. Several hiking paths, called portages, lead to wilderness streams and lakes. Although anything you can reach by driving is outside the wilderness area, you may need a wilderness permit, available from the U.S. Forest Service, to hike some trails or paddle some lakes. All BWCAW entry points are clearly marked with signs, and day-use wilderness permits are often available at the entry points.

However, you don't need to enter the wilderness to get a taste of its beauty. Burntside Lake, just northwest of Ely, is breathtakingly scenic. Clear and cold, Burntside is more than nine miles long and contains more than one hundred islands. You can get a good view of the lake

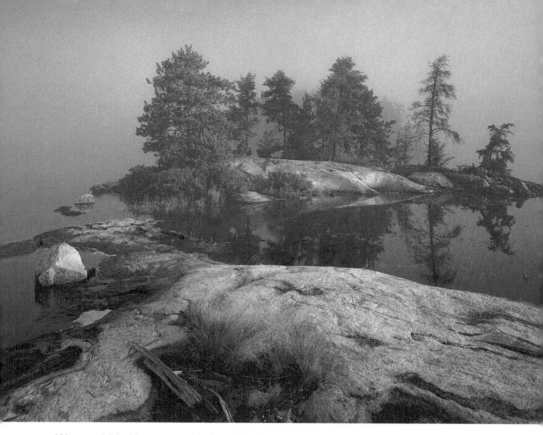

Water within Voyageurs National Park is studded with rocky islands, both big and small. More than thirty lakes cover the primitive and water-dominated Voyageurs, Minnesota's only national park.

where the Echo Trail climbs a ridge. Another place with a heck of a view is farther north, where the road passes above Ed Shave Lake.

You will need a wilderness permit—and a canoe—to visit the Indian pictograph site on North Hegman Lake. You must first carry your canoe across a 120-rod portage to South Hegman Lake, paddle across it, and make a 5-rod portage to North Hegman. The pictographs are on the cliffs along the west shore. Pictographs—figures and symbols painted on rocks with natural pigments—are found along waterways throughout the canoe country. They are believed to have been painted by the Ojibwe, probably during the last several hundred years. The North Hegman Lake pictographs are among the best-known sites.

The Angleworm Trail is one of two extensive BWCAW hiking loops along the Echo Trail. The scenic trail circles Angleworm Lake and is 13.5 miles long. At 32 miles in length, the minimally maintained Sioux-Hustler

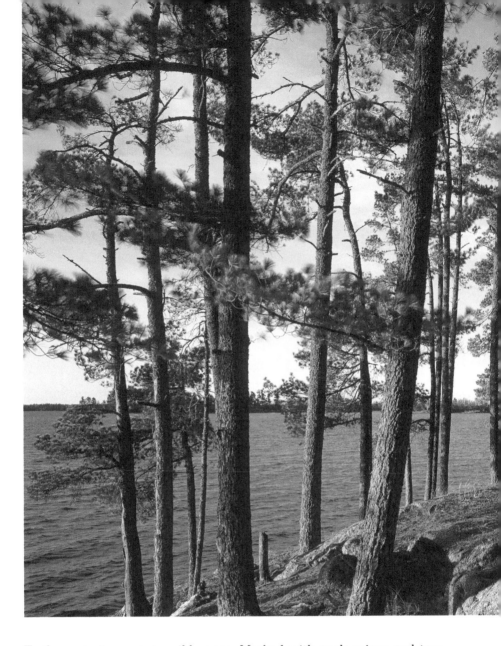

Trail penetrates remote wilderness. Marked with rock cairns and tree blazes, this is not a path for the casual stroller. The high point for hikers is the Devil's Cascade, a waterfall on the Little Indian-Sioux River.

Less adventuresome hikers can consider the portage trail to Stuart River, where you walk among old white pines. A short loop from a roadside pull-off on the Echo Trail overlooks an area along Range Line Creek that was burned over by the Little Indian-Sioux fire in 1971.

Iconic white pines shelter a shoreline on Lake Kabetogama in Voyageurs National Park.

You may encounter wildlife anywhere along this route, especially early and late in the day. You may even see something unusual—like river otters romping on the boat docks at Crane Lake. This end-of-the-road resort community is located north of the Echo Trail's western terminus with County Road 24. Crane Lake is the gateway to a quarter-million acres of wild lakes and waterways. It is the eastern entry point to Voyageurs National Park and the beginning of water routes

THE BOUNDARY WATERS CANOE AREA WILDERNESS

THE "B-DUB," AS THE CANOE COUNTRY is known to many paddlers, is the nation's most popular wilderness area. Encompassing over one million acres along the U.S.–Canada border, the wilderness is mostly closed to motorized travel. In summer, visitors traverse the area in canoes, carrying both the craft and their gear across portage paths between the lakes. In the winter, the best way to travel the frozen lakes is with a dog team, although many visitors choose cross-country skis or snowshoes.

The Boundary Waters seems to attract two kinds of visitors: those who fish and those who seek a "wilderness experience." Anglers will find some of the nation's best fishing for walleye, smallmouth bass, northern pike, and lake trout. Non-fishing folks will find pristine, pine-studded surroundings and rugged, undeveloped terrain.

The preservation of the Boundary Waters was a decades-long political struggle that culminated by Congress designating the area as wilderness in 1978. The eloquent writings of the late Sigurd Olson, an Ely resident, helped shape the public's view that this wild place was worth protecting. Today few disagree.

On July 4, 1999, a fierce windstorm crossed the wilderness and left a swath of downed trees in its wake. Although it changed the character of the landscape in some portions of the wilderness, it did not diminish the Boundary Waters' popularity with adventure-seeking paddlers. You can see evidence of the blow down along the Fernberg Road and elsewhere near Ely, although it may be difficult to distinguish the effects of the windstorm from logging operations. Indeed, much of the wind-felled timber outside the wilderness area was salvaged by loggers after the storm to reduce fire risk.

into Canada. A Canadian customs station beyond the King Williams Narrows on Sand Point Lake is accessible only by boat or seaplane. Vermilion Gorge on the west end of Crane Lake can be reached by hiking or boat. However, the best way to see this water wonderland is to go fishing. Excellent local guides can help you catch walleyes and show you the sights.

ROUTE **6**

Renaissance in the Woods

ELY, VIA HIGHWAY 1
AND FERNBERG ROAD

Directions From Minnesota Highway 61, turn north on Minnesota Highway 1 at Illgen City. When you reach Ely, turn east on U.S. Highway 169, which becomes Fernberg Road (County Road 18).

Minnesota Highway 1 is northern Minnesota's Route 66—a ribbon of two-lane blacktop running from Lake Superior west to the North Dakota border. As Minnesota's northernmost east-west route, the highway crosses the state's sparsely populated northwoods.

The stretch between the North Shore and Ely is arguably Minnesota's most outstanding forest drive. However, it is not a road for hurried travel. Cruise control is out of the question on this rugged, winding route. Leaving Lake Superior, you climb through the Sawtooth Mountains, following the Baptism River to Finland, which is still populated with descendants of the original Finn settlers. Then through the woods you go, passing only Murphy City—a railroad outpost—and the tiny logging community of Isabella. North of Isabella, pines and spruce crowd the twisting highway. The northwoods envelop you.

This is a drive worth taking at any time of the year. At dawn or dusk in June, you may see moose wallowing in the muddy ditches between Finland and Isabella. In autumn, the rocky hillsides of the Baptism River valley south of Finland are splashed with fiery color. In winter, this serpentine road is often slow and slippery, but that gives you more time to enjoy the ethereal beauty of the snowy pines and frozen lakes.

Seemingly endless gravel forest roads head into the woods, leading to dozens of small lakes and trout streams. Most forest roads are

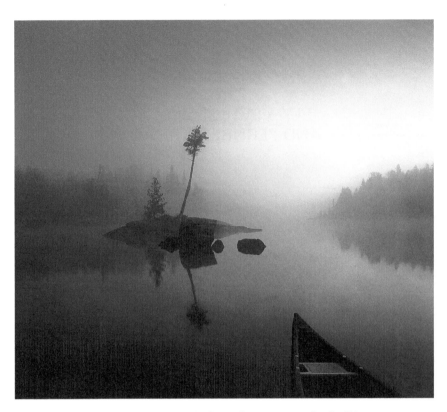

The still beauty of a misty dawn defines the essence of a "wilderness experience" in the Boundary Waters.

marked with signs, but backwoods explorers should carry a Superior National Forest map. Moose, deer, and black bear are common. A somewhat uncommon bird, the spruce grouse, may be seen picking grit along the roadside. (Spruce grouse have darker plumage than the familiar ruffed grouse.)

The northern forests are also home to the gray wolf. You can never count on seeing a wolf in the wild, but sooner or later, most northwoods travelers encounter one—usually when least expected. The best place to see one of these shy critters and learn more about them is at the International Wolf Center in Ely, which has superb natural history displays and a captive wolf pack. However, wild wolves are common around Ely and can be seen—though never predictably—throughout the year.

Ely is a renaissance town. During most of the twentieth century, it was a rough-and-tumble mining and logging community, located literally at the end of the road. Changing times and a changing economy have transformed Ely into an upscale tourist mecca. The downtown district retains its frontier flavor and has an array of shops where you will find excellent quality, locally manufactured clothing and outdoor products. Enjoying the great outdoors is what this town is all about. Ely is the gateway to the vast Boundary Waters Canoe Area Wilderness, a labyrinth of wild lakes accessible only by canoe.

You can't drive a car into the wilderness, but you can taste the flavor of the canoe country along the Fernberg Road, which penetrates the BWCAW in a nonwilderness (but wild) corridor east of Ely. Make a short detour into Winton, where century-old homes and other buildings remain from the prosperous heyday of timber and iron. Then follow the Fernberg into the woods. Public access sites at Fall, Moose, and Snowbank Lakes, as well as at road's end on the South Kawishiwi River, are great places to stretch your legs, toss stones in the water, and meet paddlers who are embarking on or returning from the canoe country. In July and August, check the clearings and jack pine forests for blueberries. Hunting for ruffed grouse is popular in the fall.

Wilderness recreation is a big business in Ely, where vacationers rent canoes to travel in the Boundary Waters Canoe Area Wilderness.

PAGES 64-65: The fall cover season in the Boundary Waters begins in mid-September and lasts until early October.

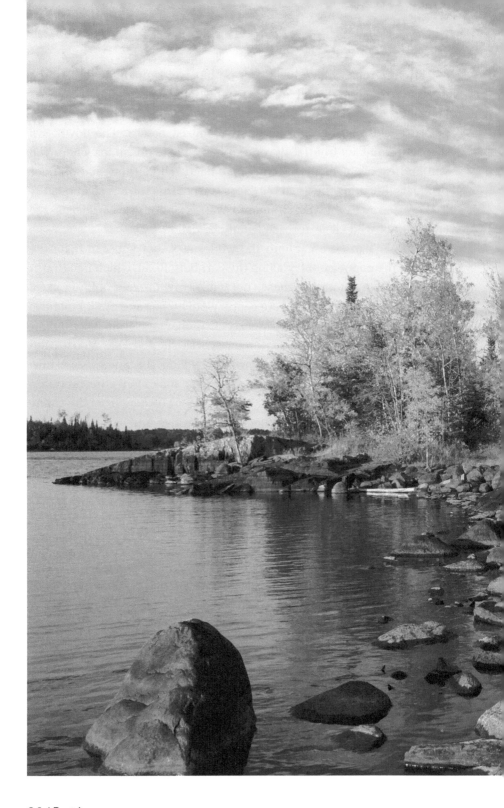

Home on the Range

FROM HIBBING TO TOWER
ON HIGHWAY 169

||

Directions At Hibbing, go east on U.S. Highway 169. When you reach Virginia, follow Minnesota Highway 135 through Gilbert and Biwabik. Back track to U.S. 169 and follow it north to Tower and Vermilion Lake.

||

The Iron Range is not noted for its natural beauty. This is a place where there are big holes in the ground—open-pit mines—with mountain-like heaps of rocky leftovers beside them. Throughout the twentieth century, the red iron ore discovered here in the late 1800s played a key role in the industrial development of the United States, supplying the raw material for Henry Ford's cars, the tanks and weaponry that won World War II, and the material goods of the Baby Boom. Without the Iron Range, America would be a different place.

In another sense, the Range is America. Immigrants of forty-six nationalities came here to find work and raise their families. People who spoke many languages had to learn how to communicate in a common tongue while working together in the mines. To this day, this melting-pot past is reflected in the distinctive dialect of the Iron Range people. Go to a busy cafe and listen to the people talk—you'll hear it.

OPPOSITE: Winter arrives early in the Arrowhead, where October snowfalls are not unusual. Here the Kawishiwi River seems reluctant to freeze.

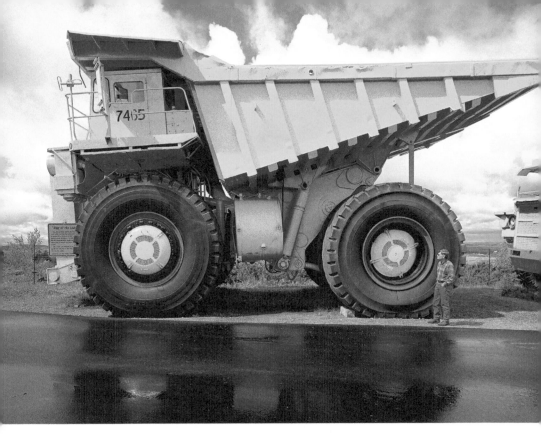

The monstrous, ore-hauling trucks used on the Iron Range are sure to strike child-like awe in anyone.

In Tower, a painted brick advertisement has long outlasted the advertiser.

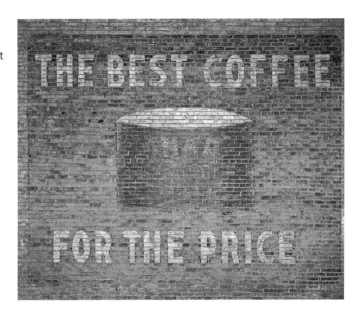

The best place to learn about the rich history of the Iron Range is at a theme park/historical center west of Chisholm called the Ironworld Discovery Center. Built beside a former open-pit mine, it has interactive displays that tell the story of iron mining. During the summer, a series of ethnic festivals and music events celebrate the melting-pot heritage of the Iron Range.

Another historical center of note in Chisholm is the Minnesota Museum of Mining. Housed in a stone castle built as a Works Progress Administration project in 1933, the museum contains a 1910 Atlantic steam shovel—a prototype to the steam shovels used to dig the Panama Canal.

If you want to see a really big hole in the ground—one of the largest such holes anywhere in the world—check out the Hull-Rust-Mahoning Mine outside of Hibbing. The huge, open-pit mine is a national historic landmark.

Hibbing, the largest community on the Iron Range, has a special claim to fame as the hometown of folk musician Bob Dylan. Back then, of course, he was known as Bobby Zimmerman. This is also the birthplace of Greyhound bus. No tour of Hibbing is complete without driving past the city's magnificent high school. The school is a monument to the importance that miners and the steel companies that employed them placed on educating children. Although the immigrants who settled the Iron Range often had little formal education, many of their descendants earned college degrees.

At Eveleth, beside U.S. Highway 53, is the U.S. Hockey Hall of Fame. The Iron Range may not have been the American birthplace of hockey, but the sport has a long, proud tradition here. Nearby Virginia serves as the modern retail center of the Range. However, walking through downtown Virginia you can get a glimpse of the past amid the cluster of storefronts.

Going east from Virginia, the route becomes more interesting. Up to this point, U.S. Highway 169 has been a four-lane thoroughfare. Minnesota Highway 135 is a twisting, two-lane road. Some of the hills you pass are the rocky spine of the Iron Range. Others are piles of rock waste from the mines.

At Biwabik is a high, natural hill called Giants Ridge. This may seem an unusual location for a major ski resort, but the Giants Ridge

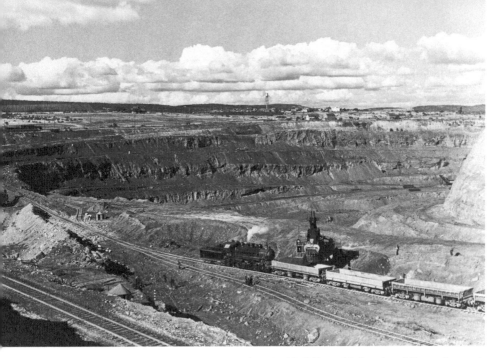

One of the world's largest open pits, the Hull-Rust-Mahoning Mine, pictured here in 1940, provided iron ore during World War II. *Courtesy of the Minnesota Historical Society*

recreation area offers both downhill and cross-country skiing, as well as golf in the summer. A few miles east, the highway turns north and passes through a forest broken with occasional clearings. Today most of these clearings are hayfields, but the area once supported many small farms. The settlers here were largely of Finnish descent, attracted to a place that reminded them of their homeland. If you pay attention, you can see the moldering remains of log buildings those settlers built.

Highway 135 ends at Tower, another town with a mining history. The initial surge of settlement was sparked by the supposed discovery of gold, which drew a flood of prospectors up the rugged Vermilion Trail from Duluth. However, like the rest of the Range, Tower has an iron foundation. The first iron-ore mine was here. The ore was shipped by rail to the Lake Superior port of Two Harbors beginning in 1884. High-grade iron ore was a cornerstone of the local economy until the 1950s, when the mining industry shifted to taconite, a low-grade ore that is refined for higher iron content. Taconite wasn't produced in Tower, but mines exist in nearby Babbitt.

Tower is the home of the unique Soudan Underground Mine State Park, where visitors can take a guided tour that goes one-half mile underground. Early mining operations like the Soudan Mine were not open pits, but instead consisted of a network of underground shafts. Down, down, down you go, then you explore horizontal shafts with a ride on narrow-gauge rail cars. At one point in the tour the lights go out, and you experience the sensation of total darkness. This tour may not be for everyone, especially the claustrophobic, but you won't find anything comparable elsewhere in Minnesota. Wear a jacket, because it's chilly down there.

The Soudan Mine has long since ceased operation. Today the economy of Tower is largely based on tourism and logging. Mighty Vermilion Lake, on the northern edge of town, is a popular attraction for boaters and anglers seeking walleyes, muskies, and smallmouth bass. A beautiful body of water, Vermilion lies just outside the Boundary Waters Canoe Area Wilderness, which means that visitors can enjoy the northwoods atmosphere while staying at a comfortable resort and using a motorboat.

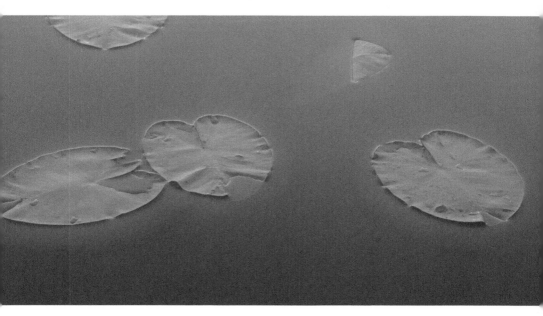

Water lilies are common in shoreline shallows and are a favorite summer food for moose.

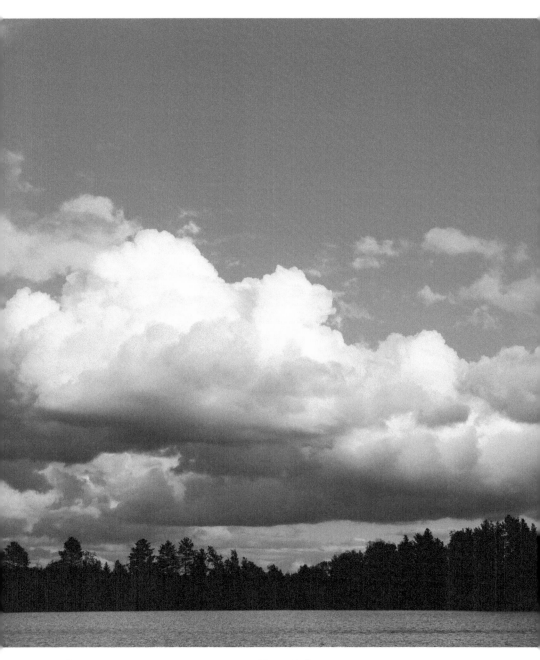

Brooding clouds cast a shadow on Moon Lake.

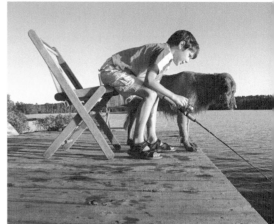

Vermilion Lake, home of
Minnesota's newest state park,
is famed for pristine shorelines
and fabulous fishing.

PAGES 72-73: On the Iron Range,
a century of mining has
transformed the landscape,
but the scenery remains.

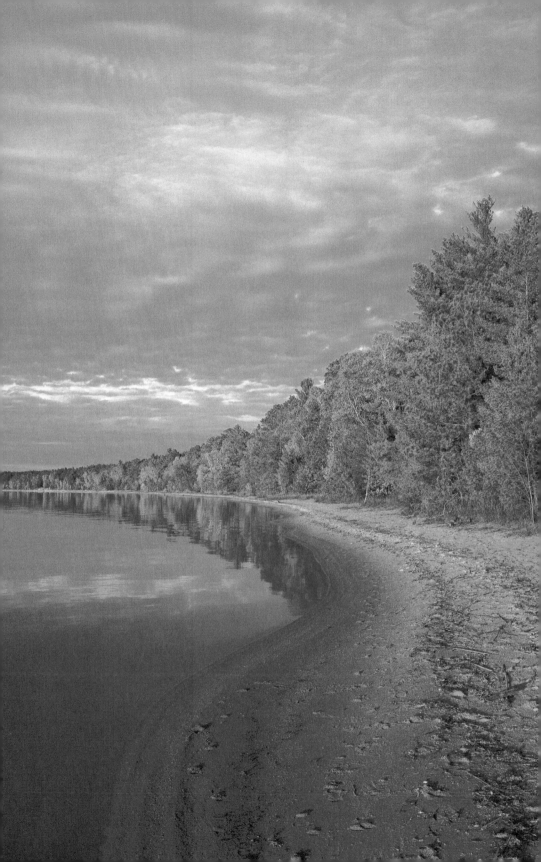

North-central Lake Country

Tall Pines and Clear Waters

F or Minnesotans, "up north" is as much a state of mind as it is a destination. It's a getaway, a refuge, a fond memory. "Up north" is a personal thing, but it is also part of our collective Minnesota consciousness. The wind whispering in the northwoods pines blows through all of us. We all know a place where there is a cabin beside a sparkling lake. We have all heard the call of the loon.

OPPOSITE: The undeveloped shoreline of Cass Lake is an inviting place to beach a boat and go for a walk.

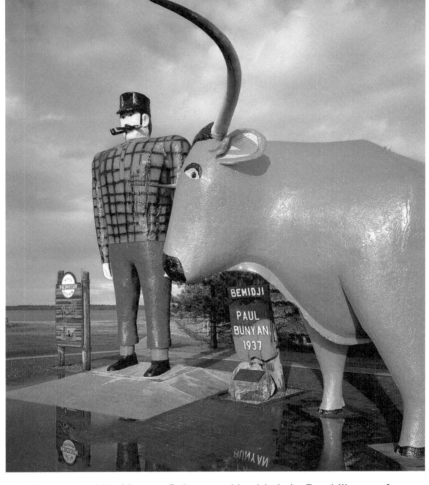

Paul Bunyan and his blue ox, Babe, stand beside Lake Bemidji, one of thousands of northern Minnesota lakes said to be formed by the mythical lumberman's footprints.

For many, such experiences have occurred in the lake country of north-central Minnesota. Situated at the headwaters of the Mississippi River, this region is splashed with water. There are large lakes, like Mille Lacs, Leech, Winnibigoshish, and Cass, and thousands of smaller water bodies. Laced between the lakes are quiet creeks and streams, shaded by an endless forest. Life on the water is part of the northwoods culture.

It is not an accident that there are a number of Ojibwe communities here. The lakes provided fish, fowl, and wild rice for native people. Today the tradition of living with the land continues. In addition, the

lakes are tremendously important resort and recreation areas. This is Minnesota's most famous fishing region. Swimming, boating, and soaking up sun on the beach are popular, too.

Forests in this part of the state are mostly public. In addition to the massive Chippewa National Forest, there are numerous state and county forests. Like the lakes, the forests have shaped the northwoods culture. Loggers made their way into this country in the 1800s, drawn by the abundance of huge pines. Cutting down giant trees by hand was backbreaking labor performed in the dead of winter, but the loggers, logging camps, and spring river drives became the stuff of legend. The story of Paul Bunyan may be a tall tale, but he personifies a history that is, in many ways, larger than life. If you look in the forest, you can find evidence of that history.

You can also see the handiwork of a later generation that, in the midst of the Great Depression, sent men to the woods to plant trees, build forest roads, and construct recreational facilities. We continue to reap the benefits of the public works completed by the Civilian Conservation Corps.

Today when you roam this land of lakes and woods, you'll find a place that has changed in the past century but still remains *au naturel*. A second-growth forest of deciduous and coniferous trees has replaced the mighty pines and provides raw material for the still-flourishing timber industry. At places like the Lost Forty west of Bigfork and Itasca State Park, you can find remnants of the ancient pine groves. Wild rice remains abundant in many waterways and is still harvested in early autumn. You could spend a lifetime fishing in the region and never run out of new lakes to explore. Nearly all the waters feed the mighty Mississippi, and it is humbling to realize a raindrop that falls here eventually winds up in the Gulf of Mexico.

Drive around Mille Lacs at spring ice-out when the wind tosses piles of ice cakes onto the beach. Seek out the history of logging in Grand Rapids, then drive north through the forest to the Lost Forty. Go fishing in Leech or Winnibigoshish Lakes. Visit with Paul Bunyan in Brainerd, Akeley, or Bemidji. Skip across the Mississippi on stepping stones at Itasca State Park, then watch the river grow by following it downstream along the Great River Road. No matter where you go in north-central Minnesota, you'll quickly slip into an "up north" state of mind.

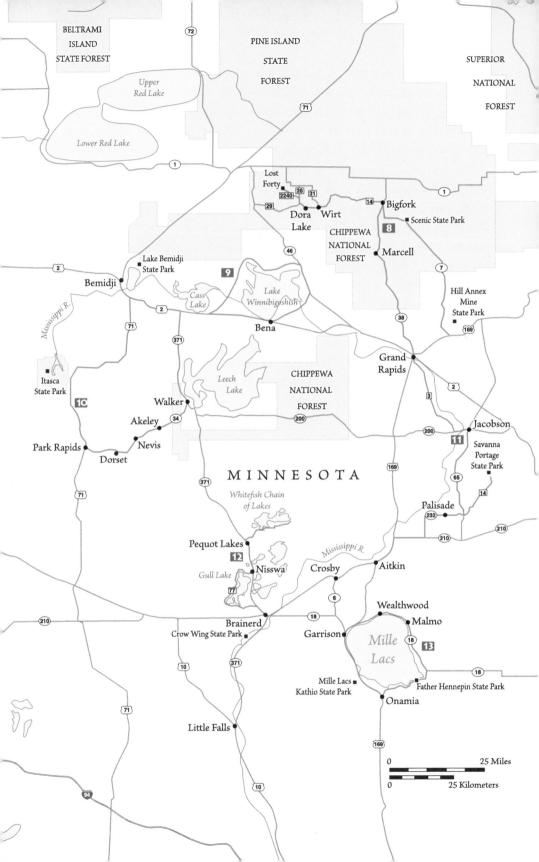

At the Edge of the Wilderness

HIGHWAY 38 AND BEYOND

Directions Minnesota Highway 38 goes north from Grand Rapids. At Bigfork, turn west on County Road 14. East of Wirt, pick up County Road 29 going to Dora Lake. From there, follow County Road 26 north, then Forest Road 2240 west to the Lost Forty. Then retrace your path to Bigfork and follow Minnesota Highway 7 back to the Iron Range—just east of Grand Rapids.

Shaded by hardwoods and tall pines, Minnesota Highway 38 takes a sinuous, undulating path through an expanse of forest between Grand Rapids and Effie. Only a fool would drive quickly on a highway such as this. And only a wanderer with no sense of adventure would fail to stop at the many interesting way points along this route. Bring your curiosity and a pair of hiking boots.

The U.S. Forest Service lists Highway 38 as a National Scenic Byway and directs travelers to points of interest. The first, just north of Grand Rapids, is the Lind-Greenway Mine. Now closed, the mine is on the western edge of the Mesabi Iron Range. As is so often the case in northern Minnesota, a short physical distance separates this developed area from wilder places. The highway snakes through lake country, occasionally emerging from the trees to pass beside a lakeshore.

A few miles to the north is the Trout Lake Semi-primitive Non-motorized Area, which preserves a wild tract once known as the Joyce Estate. A round-trip walk from the Blue Water Lake Road to the site of this once-private retreat is three miles. Just up the highway is another non-motorized area called Suomi Hills, which was named for a tiny, Finnish logging community. Trails here are used for hiking, mountain biking, and cross-country skiing. A local natural wonder is Miller Lake, where a beaver dam at the outlet occasionally washes out

In autumn, northern Minnesota's "sky-blue waters" become colorful reflecting pools, such as this example on Dead Horse Lake.

and significantly drops the lake level. You can walk to Miller Lake from a trail beginning on Forest Road 2153.

North of Suomi Hills, you cross the Laurentian Divide, a height of land marked by a sign. South of the divide, water flows southward through the Mississippi River to the Gulf of Mexico; north of the divide, waters flow northward to the Rainy River, Lake of the Woods, and on to Hudson Bay. The first north-flowing water you can admire is appropriately named North Star Lake. A short trail from the boat access on the west side of Highway 38 leads to an overlook. A decaying railroad trestle visible in the lake dates to the logging era of the early

OPPOSITE: Stately red pines grace the shores of Orange Lake in the Chippewa National Forest.

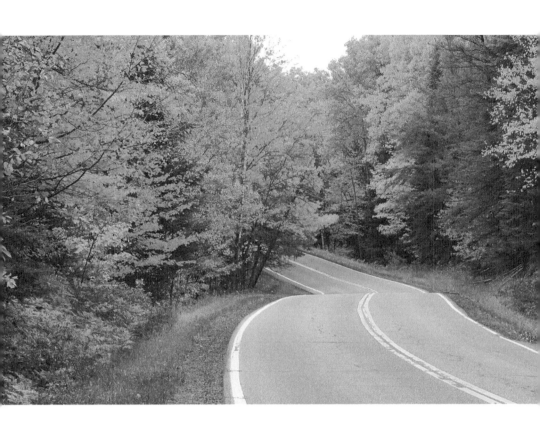

ABOVE: Highway 38, a nationally designated scenic byway, winds through Chippewa National Forest.

OPPOSITE: The Chippewa National Forest visitors center is housed in a massive log building, built by the Pike Bay Civilian Conservation Corps in 1935.

THE LOST FORTY

In August, when it is sticky hot in the afternoon, deer flies as big as bumblebees buzz in the still forest. Amid the ancient red and white pines on the Lost Forty, that's about the only sound you'll hear. A quiet path leads you among the trees, which were spared the axe by mistake. In 1882, Josiah King and a three-man survey crew accidentally mapped this plot, which is actually 144 acres, as part of nearby Coddington Lake. It was never logged as a result.

The 350-year-old pines are twenty-two to forty-eight inches in diameter. Once trees like this were abundant from the St. Croix Valley to the Canadian border, but most pine stands were cut down during the late 1800s and early 1900s. The Lost Forty is one of the best surviving examples old-growth pine.

The path through the pines is less than a mile long and a fairly easy walk. You can see the oldest trees by walking just a short distance along the path from the parking area. Look for V-shaped fire scars at the base of the trunks. Fire is part of the pine tree's life cycle, and prior to fire prevention efforts, wildfires swept through the forest every thirty to fifty years. Thick bark on the pines protected them from the flames, which scarred but didn't fatally girdle the trees. Pine seedlings sprouted on the open ground in burned areas.

1900s, when logs were gathered on the lake and floated downstream in the spring. Of equal age is the small northwoods community of Marcell. The town was moved to its current location from nearby Turtle Lake in 1911, in order to be near a new railroad spur. The U.S. Forest Service district ranger station at Marcell has four log buildings listed on the national historic register and is a good place to get local information.

The next town along this route, Bigfork, also has a proud logging heritage that continues to the present. The timber industry is an economic mainstay. An Ojibwe couple who lived along the Bigfork River in the 1870s encountered a winter logging camp whose inhabitants were overcome by smallpox. At great risk to their own health, the couple stayed at the camp, caring for the sick and cremating the dead. They remained until the men recovered enough to care for themselves. The couple received no reward for their humanitarian act but were honored by logging camp storytellers. Today the wild Bigfork River is a northwoods gem, primarily known to a few adventuresome canoeists. It is a good place to fish for muskies.

Just north of Bigfork, turn west on County Road 14, which follows the Bigfork River upstream. Just east of Wirt, you'll pick up County Road 29. Follow that road west to Dora Lake, then turn north on County Road 26 and follow signs to the Lost Forty. After viewing the old growth pines—without question, worth the detour—backtrack to Bigfork.

Head south from town on County Road 7. Scenic State Park, a few miles south of town, offers respite from the road and places to swim, camp, and fish.

County 7 meets U.S. Highway 169 just a few miles east of your starting point at Grand Rapids. Drive east a couple of miles on U.S. 169 to Calumet, where Hill Annex Mine State Park preserves the history of open pit iron mining. Here you can take a one-hour tour of the Hill Annex Mine, once the sixth largest producer of iron ore in the United States and now a National Historic Site.

OPPOSITE: While winter won't officially arrive for another two months, early snows often add contrast to autumn colors.

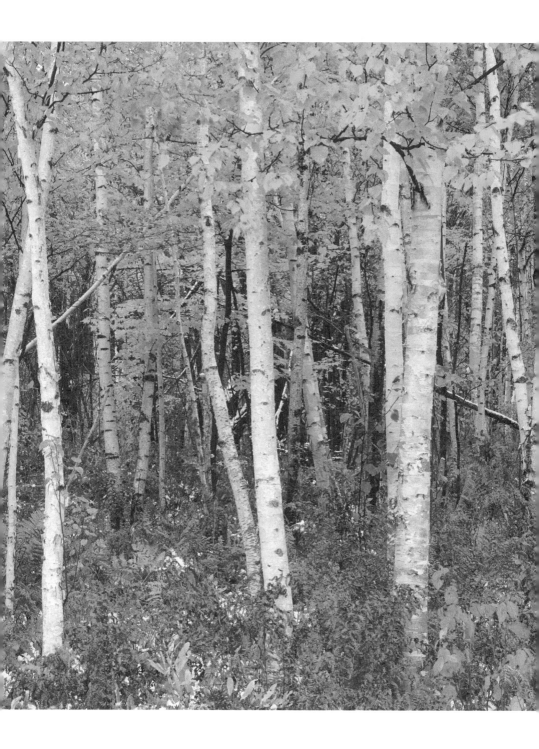

Winsome Winnibigoshish

LAKE WINNIBIGOSHISH
AND CASS LAKE

||

Directions Starting at the Winnigishish Dam, go east on County Road 9 to Minnesota Highway 46. Follow the highway north to County Road 33, then go west to Forest Road 2171. Head south on the forest road to U.S. Highway 2.

||

There is a campground and a park where the Mississippi River runs out of Lake Winnibigoshish. On a sunny, early summer morning, it is a pleasant place. The woods are newly green. The air is sweet. Water spills over the dam, becomes a river, and sparkles through the park. Anglers cast from the bank, hoping for walleyes but catching mostly northern pike.

From the park, you can walk across the road, which crosses the dam, and look across mighty Winnie. From here, you can see less than one-third of the lake, but it's still an impressive view. The shorelines are wooded with aspen, birch, and conifer. Bulrushes emerge from the wave-washed shallows. Fishing boats bob offshore. All and all, the dam at Winnie is a fine place to start your morning—and begin a backroads drive around the big lake.

At 58,500 acres, Winnie is one of Minnesota's largest lakes. Best described as a relatively shallow basin, it is one of several large lakes in the Mississippi River's upper reaches. Surrounded by the Chippewa National Forest, most of the lake's shoreline is undeveloped. Wild marshes in secluded bays attract large numbers of migrating waterfowl. In the summer, the open lake is dotted with fishing boats carrying anglers seeking walleyes and muskies. Many Wisconsin ice-anglers make winter Winnibigoshish pilgrimages to catch yellow perch—a Dairy State delicacy.

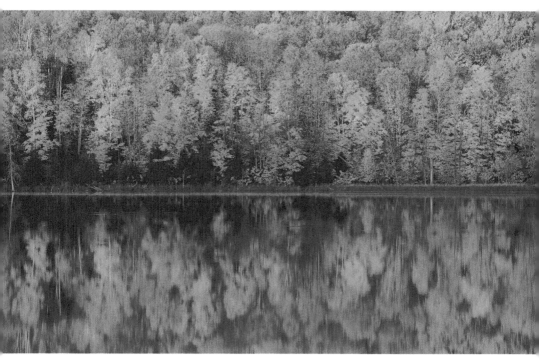

Autumn arrives on Long Lake in the Chippewa National Forest.

Popular with vacationers today, this area also has a long human history. At Winnibigoshish, native people found fish, fowl, and grain—wild rice was a staple food. Northern Minnesota's native people have an enduring association with wild rice, once a vital winter food and, after European settlement, a source of income. Wild rice grows best where clear, shallow water flows over a soft bottom. That is why it is most often found in river systems such as the upper Mississippi and its tributaries, or in spring-fed lakes and marshes. Today, much of the "wild" rice sold commercially is grown in paddies, although you can find the real thing for sale in north-central Minnesota. Rice harvested in the wild has a green tint, while paddy-grown kernels are hard and black.

In late August and September, rice harvesters work in pairs. One poles a canoe while the other sits in the bow and taps the ripe grains from the stalks with two sticks. Lake rice is typically long-grained and prized for cooking. Rice in streams is short-grained and sometimes referred to as "duck rice." Harvesting rice is one thing, finishing it for

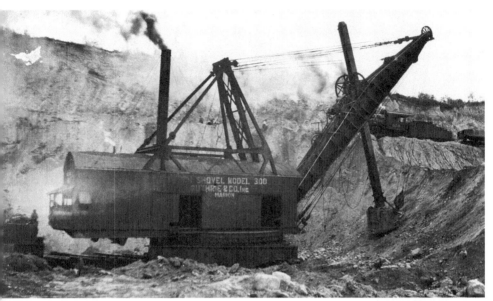

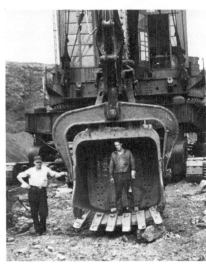

ABOVE AND RIGHT: Huge shovels were used to scoop up the iron ore at the Hill Annex Mine. *Courtesy of the Minnesota Historical Society*

cooking is another. The rice is parched to reduce moisture content and winnowed to remove the sheath that covers the seed—a time-consuming process when done by hand. Many harvesters prefer to take their rice to professional finishers instead.

Going north on Minnesota Highway 46, you'll find Turtle Mound and Cutfoot Sioux Lake. The Dakota built the turtle-shaped mound after a victorious battle with the Ojibwe. After the battle at Cutfoot Sioux,

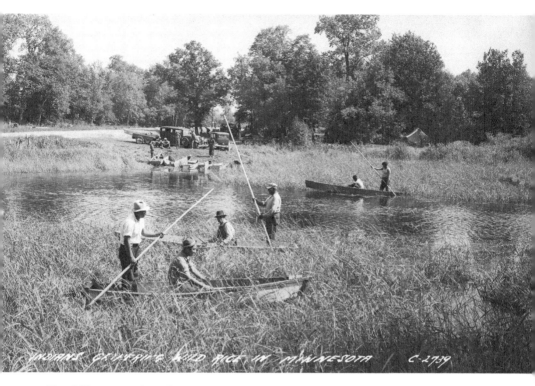

The Ojibwe people still harvest wild rice using the traditional methods shown in this 1939 photo. *Courtesy of the Minnesota Historical Society*

the Ojibwe gained dominance in the region. Lakes called Drumbeater, Bowstring, and Ball Club (used in an Ojibwe game) also denote the area's native heritage. Sugarbush Point, named for its sap-producing maple trees, extends between Winnie and Cutfoot Sioux Lakes. Today the Winnibigoshish area is within the boundaries of the Ojibwe's Leech Lake Indian Reservation. During the summer, traditional powwows are held in the area.

Highway 46 is called the Avenue of the Pines. It is named not for the original stands of white and red pine the first lumbermen found here; instead it commemorates the extensive pine plantations that the road passes. Tall, stately, and growing in orderly rows, the pines are a contrast to the chaos of vegetation in a natural forest. Logging has a long history here and remains important to the local economy. Moldering in the forests are old logging camps, artifacts from the era of

big pines and lumberjacks. If you pay attention to the passing forests, you'll notice places that were recently logged, young forests, and mature stands of trees.

Pines remain a component of the mixed hardwood and conifer forests, but many areas are dominated by aspen. A tree that quickly sprouts following a forest disturbance such as fire or logging, aspen grows quickly and can be harvested every forty to sixty years. It is used by the forest products industry to make paper and building materials.

PAGES 88-89:The sun sets over Cass Lake, one of several large lakes feeding the Mississippi River as it begins its journey to the Gulf of Mexico.

The lupine is a common roadside flower in north-central Minnesota lake country.

You can follow either county or forest roads, such as County Road 33 and Forest Road 2171, around the north and west sides of Winnie. Various public campgrounds and boat launches offer views of the lake. When you reach U.S. Highway 2, go west to Cass Lake, where you'll find the Chippewa National Forest Headquarters. Cass Lake and Pike Bay, which you'll see on the south side of U.S. 2, are famous for walleye and muskie fishing. Lake Windigo, on Cass Lake's Star Island, has local fame as a lake within a lake.

CHIPPEWA NATIONAL FOREST

IF YOU SET OUT TO EXPLORE all of the fishing holes within the Chippewa National Forest, it would take a lifetime. Within the forest boundaries are 1,300 lakes and 923 miles of river. In addition, there are 400,000 acres of wildlife-rich wetlands. The waterways are mostly part of the Mississippi River's uppermost reaches, and include such famous lakes as Leech, Cass, and Winnibigoshish. Fishing, boating, camping, and hunting are popular recreational activities.

The "Chip" contains a mix of trees, including aspen, birch, red pine, white pine, and maple. Towering stands of pine can be found throughout the forest, with the best-known being the Lost Forty, a never-logged grove. With so many tall pines and an abundance of water, it is not surprising that the forest is home to numerous pairs of nesting bald eagles. Sightings of the majestic birds are commonplace.

The forest headquarters at Cass Lake is housed in a superbly crafted, Finnish-style log building. The 8,500-square-foot building was built by Civilian Conservation Corps and Works Progress Administration crews and opened to the public on April 1, 1936. The centerpiece of the building is a massive 51-foot-high fireplace made of split and matched glacial boulders.

ROUTE 10

At the Source

WALKER, LAKE ITASCA, BEMIDJI, AND LEECH LAKE

Directions Starting in Walker, go west on Minnesota Highway 34 to Park Rapids. Go north on U.S. Highway 71 to Itasca State Park. From the park, follow the county roads marked with Great River Road signs to Bemidji. Take U.S. Highway 2 east to Cass Lake and turn south on Minnesota Highway 371 to go back to Walker.

Winters are long in Walker. Frozen Leech Lake is as cold and forbidding as the Arctic, but this does not deter the ice fishers. In December, January, and February, they roam the ice, lowering lines through augured holes. What they seek are walleyes. What they catch are eelpout.

A freshwater cod that lives on the bottom of northern lakes, the primordial eelpout is one ugly fish—one that most people instinctively don't want to touch. A single barb protrudes from the chin of its flat head, behind which is the body of a pot-bellied snake. Its mottled coloration—which acts as camouflage on the lake bottom—can be politely described as earth tones. A self-respecting Minnesota angler generally won't boast about catching or eating eelpout, except during one weekend in February when Walker celebrates the eelpout with an on-ice festival. Then "walleye" is a dirty word.

If an eelpout extravaganza isn't your cup of tea, head for this backroad destination when the weather is warm. The lakes and resorts around Walker, Park Rapids, and Bemidji are some of the state's finest. Minnesota Highway 34 passes through the tiny towns of Akeley (don't miss the Paul Bunyan statue), Nevis, and Dorset on its way to Park Rapids. Actually, Dorset is a short distance north of the highway, on Minnesota Highway 226. If you're hungry, make the detour, because this

Itasca State Park contains Lake Itasca, the source of the Mississippi River, and some of the state's largest stands of old-growth red and white pine.

village has more restaurants per capita than anywhere else in the state. Park Rapids lies along the transition between forest and farmland, and it features historical exhibits of pioneer logging and farming.

In October, fall colors and sparkling blue lakes create a lovely roadside palette along U.S. Highway 71 going north from Park Rapids to Itasca State Park. The crown jewel of Minnesota's state park system, the park protects Lake Itasca, the source of the Mississippi River. Many explorers tried to find the river's headwaters, but they weren't discovered until 1832 by Henry Schoolcraft, who was traveling with an Ojibwe guide. The lake and much of the surrounding area became Minnesota's first state park in 1891.

The layered bark of a red pine forms a colorful mosaic.

When you visit Itasca State Park, plan on spending some time there because it offers so much to see and do. At the lake's outlet you can walk across the start of the Mississippi on steppingstones. Virgin pine forests are a hallmark of the park, and the state's largest white and red pines are found here. Preachers Grove, a stand of red pines, started growing after a fire in the early 1700s. Be sure to take the eleven-mile Wilderness Drive and walk the Bohall Trail to the heart of a two-thousand-acre wilderness sanctuary. The Bison Kill Site is an archeological dig of a prehistoric hunt that occurred seven thousand years ago. Douglas Lodge, on Lake Itasca's east arm, is an enormous log structure built between 1904 and 1906. Several other log buildings were built during the Great Depression.

From Itasca, you can follow the various Clearwater, Hubbard, and Beltrami county roads that make up the Great River Road, clearly marked with the byway's green-and-white paddleboat logo signs, to Bemidji. On the shores of Lake Bemidji loom one of the region's three statues of Paul Bunyan and Babe the Blue Ox. Tall tales are told of this dynamic duo, who roamed the woods where the tall pines grew. For instance, the skillet in Paul's cook shack was so big that several boys would strap slabs of bacon to their feet and skate around to grease it. When it rained, Paul and Babe's footprints filled with water, creating northwoods lakes. You can learn more about Paul Bunyan, and Bemidji, at the nearby Bunyan House visitor center and museum.

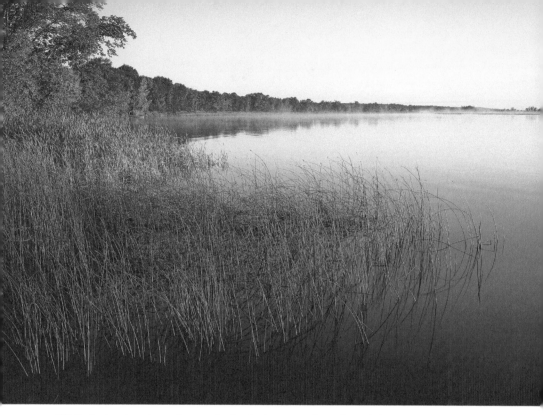

While bulrushes have been eliminated or greatly reduced due to development on many Minnesota lakes, extensive stands exist on Leech Lake, providing essential fish and wildlife habitat.

Lake Bemidji State Park, located north of town, has an unusual bog boardwalk that offers an opportunity to learn more about northern wetlands. The boardwalk takes you through marshland underneath a canopy of tamaracks, a common bog tree and the only conifer that drops its needles annually. The bog is strikingly beautiful when the tamaracks turn gold in October.

Lake Bemidji is the first of the large, northwoods lakes along the Mississippi's course. Downstream the river passes through small lakes before reaching Cass and then Winnibigoshish Lakes. You can follow U.S. Highway 2 to Cass Lake and then turn south on Minnesota Highway 371, which follows the west shore of Leech Lake's Walker Bay. Interestingly, Leech isn't located on the Mississippi's main stem. The Leech Lake River flows out of the northeast end of the lake at Federal Dam, passes through the vast Mud-Goose Wildlife Management Area, and enters the Mississippi downstream from Winnibigoshish.

ROUTE **11**

The Great River Road

FROM GRAND RAPIDS TO AITKIN

‖‖

Directions From Grand Rapids, go south on County Road 3, which becomes County Road 10 a few miles west of Jacobson. Either continue south on County 10 directly to Palisade, or cross the river on Minnesota Highway 200 and continue south on Minnesota Highway 65. From Highway 65, follow County Road 14 east to the entrance to Savanna Portage State Park. Back on Highway 65, just south of Big Sandy Lake, go west on Minnesota Highway 232 to Palisade. From Palisade, follow county roads marked with Great River Road signs south to Aitkin.

‖‖

Grand Rapids is a tree town. Logging and forest products are key to the community's economy and heritage. The Forest History Center, located in a wooded glen on the southern edge of town, recreates a northwoods logging camp from the early 1900s. Costumed staff members demonstrate the skills of the camp blacksmith, saw filer, clerk, cook, and lumberjacks. On the site is a floating cook shack called a "wanigan," a forestry cabin built in 1934, and a fire tower you can climb. While in Grand Rapids, follow the yellow brick road to the childhood home of Frances Ethel Gumm, who grew up to be known to the world as Judy Garland. Kids will enjoy the Garland Children's Museum.

U.S. Highway 169 runs straight and sure from Grand Rapids to Aitkin; take this route if you are in a hurry. Otherwise, there is a road less driven, an inviting route for backroads travelers. It's called the Great River Road and for good reason. The two-lane blacktop parallels America's greatest river, the Mississippi.

A good time to take this route is in the spring, before green-up, when the ducks and other birds are moving through. The river essentially offers a continuous, north-south ribbon of habitat for migrating birds.

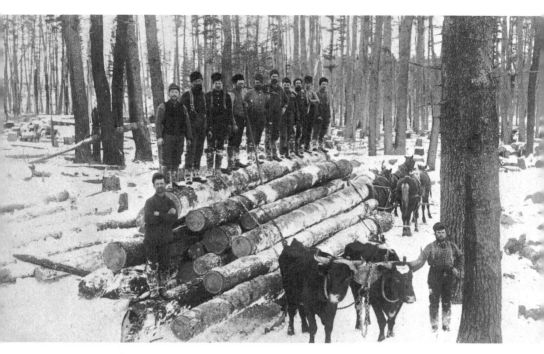

North-central Minnesota's vast pine forests provided lumber used to build the great Midwestern cities. *Courtesy of the Minnesota Historical Society*

You can expect to see many varieties of ducks along the river or in any pool of water. Look for hawks and eagles, too. During the fishing season, anglers with a canoe or small boat will find uncrowded fishing for a variety of species on the river.

Although you are never far from the Mississippi, you have but occasional glimpses of the river from the road. You could say the river doesn't let anything get too close to it. Throughout most of this stretch the Mississippi has little gradient and meanders through a broad flood plain. If you look at aerial photos of the river's course, you can see numerous sloughs and cut-off oxbows that were once part of the main channel. A fallen tree, erosion, or a shifting sand bar can all obstruct the river's flow in ways that cause the current to change. At flood stage, the surging flows can carve new channels and bisect meandering oxbows. Over time, the river's path becomes strewn with crescent-shaped backwaters that may only connect with the main stem during periods of high water.

The Great River Road follows the first ridge on the west bank. In places you can see the wooded flood plain and oxbows. The best way to get close to the water is to take side roads leading to boat landings or parks.

Just downstream from the confluence of Split Hand Creek, about halfway between Grand Rapids and Jacobson, the river enters the basin of Glacial Lake Aitkin. At this point, the river's meanders become more pronounced. A small county park at Jacobson may be worthy of a picnic, but be forewarned that if the river is high, the park may be flooded.

Cross the Mississippi on Minnesota Highway 200 at Jacobson, and then go south on Minnesota Highway 65. Along this route you'll pass Big Sandy Lake, as well as County Road 14 leading to Savanna Portage State Park. This remote park marks the location of a six-mile-long portage route used by explorers and canoe travelers during the fur-trade era to cross between the Mississippi River and Lake Superior drainages.

You can cross back over to the Great River Road by following Minnesota Highway 232 to Palisade. Between Palisade and Aitkin, the Great River Road passes through the Cayuna Iron Range. Mining no longer occurs here, but the flavor of area's iron-clad past is evident in the nearby community of Crosby, where the deep, cold waters of some flooded mine pits are stocked with trout. At Aitkin, the Mississippi bends westward and ventures over to the Brainerd lake country, where it swings south.

Aitkin is notable for the Frances Jacques Museum, an honor to the man who was arguably Minnesota's best landscape painter. Many Minnesotans are familiar with the Jacques dioramas at the James Ford Bell Museum in St. Paul. Others are familiar with Jacques's depictions of the canoe country and Midwestern wildlife. Jacques was a native of Aitkin and developed an early appreciation for the natural world here.

That natural world still surrounds Aitkin, which draws birders looking for species that prefer semi-open brush land and marsh habitat. One of those species is the yellow rail, a small, very reclusive bird that nests in area marshes. Seeking yellow rails could be compared to a snipe hunt because prospective birders are led out into the marsh at night. If you try it, don't be left holding the bag!

The Forest History Center in Grand Rapids features a reconstructed turn-of-the-century logging camp, as well as living history events, an interpretive center, and numerous exhibits.

BELOW: Well-tended farms line the banks of the Mississippi River north of Aitkin.

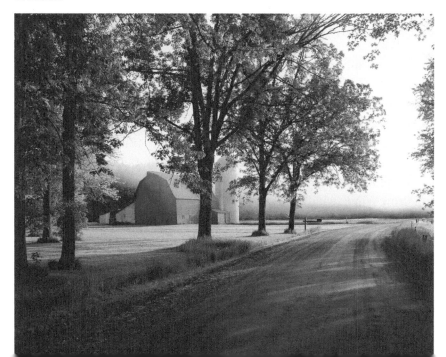

ROUTE 12

Adventures in Vacationland

THE BRAINERD LAKES AREA

Directions Starting at Crow Wing State Park, follow Minnesota Highway 371 to Brainerd. North of Brainerd, go west on County Road 77, looping back to Highway 371 at Nisswa. Continue north to Pequot Lakes, then wind east on County Road 16 through the Whitefish Chain of Lakes.

The Brainerd lakes area is Minnesota's playground. With nearly five hundred lakes, more than one hundred resorts, and fine recreational amenities, such as championship golf courses and an internationally renowned racetrack, Brainerd offers something for everyone. The only drawback, at least from the perspective of backroads roamers, is that sometimes it seems like everyone is here. Located just two hours from the Twin Cities, the Brainerd area attracts tremendous numbers of weekenders. Around town, sprawl and congestion are part of the scene.

But you can get away from the crowds. Start your adventure at Crow Wing State Park, located south of Brainerd where the Crow Wing River empties into the Mississippi River. The junction of the two rivers has a long history of human use and settlement beginning with native people. In 1768, the Ojibwe and Dakota battled here. Fur posts, missions, and logging operations were based at this location, which was the river crossing for the Red River oxcart trails. Unfortunately, when steam engines replaced teams of oxen, the railroad crossed the Mississippi at Brainerd, and the thriving community of Crow Wing lost out. Crow Wing dwindled to a ghost town. The state park preserves the history of this once-prosperous settlement. One building is restored. You can walk a boardwalk marked with signs that shows where various buildings once stood.

ABOVE: A grassy opening on the banks of the Mississippi River marks the location of the once-bustling community of Crow Wing. Once home to more than five hundred people, Crow Wing is now represented by the restored Clement Beaulieu House, scattered foundation remnants, and a few headstones. Trailside exhibits detail the history of the town.

LEFT: Nisswa and its surrounding communities have one of the largest concentrations of resorts in the state. The popular Brainerd lakes vacation area is home to more than four hundred lakes.

At Brainerd, visit the Paul Bunyan Conservation Area, which contains an arboretum that is landscaped for birds, butterflies, and other wildlife. The adjacent sand plain is a jack pine savanna preserve. Prior to settlement, much of the central Minnesota transition zone between the forest and prairie was savanna, a mixture of trees and grassland that nature maintained with frequent wildfires. Oaks were the most common trees on savannas, while jack pines grew in sandy soils.

Minnesota Highway 371 goes north from Brainerd through the heart of the Brainerd lakes country, passing through famous resort towns such as Nisswa and Pequot Lakes. Throughout the area, you'll find plenty of tourist-oriented attractions and distractions. An alternative route to Nisswa is to loop around giant Gull Lake on County Road 77.

North of Pequot Lakes, turn east on County Road 16 to wind around the southern side of the Whitefish Chain of Lakes, passing along the shores of Rush and Cross Lakes. You can stretch your legs on the walking trails in the Uppgaard Wildlife Management Area and watch wildlife from an observation blind. If you have a boat, check out Big Island on Lower Whitefish Lake. The island supports an old-growth hardwood forest and associated spring wildflowers.

The water tower in Pequot Lakes is shaped like a bobber, a monument to the area's angling heritage.

When this photo was taken in 1863, Crow Wing was a bustling frontier outpost. Abandoned in the early 1900s, the former town site south of Brainerd is now a state park. *Courtesy of the Minnesota Historical Society*

The Brainerd lakes area is the epitome of Minnesota resort country.

ROUTE 13

Around the Lake

MILLE LACS CIRCLE

Directions Beginning at Onamia, follow U.S. Highway 169 north, then County Road 26 to Mille Lacs Kathio State Park. From the park, return to U.S. 169 and follow it north. East of Nichols, follow Minnesota Highways 18, 47, and 27 around the lake, completing your circle at Onamia.

Mille Lacs is arguably the most famous lake in Minnesota. The name, a French description of a lake as big as a thousand lakes, is fitting. Standing on the beach of this vast water body, you cannot see the far shore. At 132,000 acres, it is the second largest lake wholly within Minnesota's borders. It is roughly twenty miles long and fifteen miles wide. The maximum depth is just forty-five feet. The nature of this relatively shallow expanse is that when the wind blows, the lake is tossed with huge waves. In the spring, at ice-out, windy weather can cause spectacular piles of ice to build along the shore. In some years, "ice jams" can stop traffic on the highway.

But it is not the lake's size that makes Mille Lacs famous; it is what the lake contains—walleyes, lots of them. A shallow, productive basin with good water quality and a hard bottom, Mille Lacs is a walleye factory. The thriving fish population reproduces naturally, and the lake does not need to be stocked. The lake also attracts anglers during the winter; Mille Lacs is undoubtedly one of the world's best-known ice fishing destinations. Up to five thousand plywood ice-fishing shanties are placed on the lake each winter, generally clustered as little villages over fishing hot spots.

Communities on the shores of Mille Lacs are fishing towns, with resorts, fishing launches, bait shops, and other businesses that cater to walleye anglers. To visit Mille Lacs and not go fishing is sacrilege. You don't need to be a fishing expert to have fun. You can go out on a

Were it not for ice fishing, winter in Minnesota would be much longer. More than five thousand fishing shanties are found on Mille Lacs during a typical winter.

launch, a large boat captained by a guide wise to the ways of walleyes who provides appropriate tackle and takes you where the walleyes are biting. On a launch, even beginners catch fish.

A good place to start a Mille Lacs driving tour is at Onamia, which is just south of the lake on U.S. Highway 169. Turn onto County Road 26 and follow the signs to Mille Lacs Kathio State Park, where you can learn more about the Ojibwe culture.

Mille Lacs, Minnesota's most famous fishing lake, is ruffled by a breeze at daybreak.

From the park, follow the county road north until you again reach U.S. 169—and the southwest shore of Mille Lacs. The highway runs along the west side of the lake. Pay attention, and you can find portions of an old "scenic highway," now a county road that hugs the shoreline and provides access to resorts and residences. Constructed in about 1920, this road offers a slower-paced and visually pleasing alternative to the highway.

Initial views of Mille Lacs are always awesome because the lake stretches away from you to the horizon. About four miles out from the southwest shore you can see Spirit Island, which looks like a big pile of rocks. Legends say that once an Indian maiden, or perhaps Father Hennepin, was held captive there, although there is no historical evidence that either tale is true. Today, the island is managed as a bird refuge.

Continuing north, you'll cross the lake's outlet, the Rum River, which flows south to join the Mississippi at Anoka. Just downstream from Mille Lacs are three shallow lakes, Ogechie, Shakopee, and Onamia, where the Ojibwe harvest wild rice.

The community of Vineland is part of the Mille Lacs Indian Reservation. A museum here displays exhibits of tribal history and culture, including a depiction of the seasonal cycle of traditional Ojibwe life. An adjacent structure is a re-creation of the Indian trading post that operated during the first half of the twentieth century. Be sure to check out the old gas pump out front.

Continuing up the shoreline, you'll pass Wigwam Bay and St. Alban's Bay. The forest on this side of the lake comprises mostly hardwoods such as maple and oak, with a few birch mixed in. A century ago, lumbermen felled the great white pines that grew here. Today, sightseers drive this route in the fall to see outstanding foliage.

In Garrison, the famous concourse juts out into the lake. The stonework was constructed by the Civilian Conservation Corps during the 1930s. You can drive on the concourse for a stunning view of the lake.

Continue east on Minnesota Highway 18 to follow the north shore of Mille Lacs, which goes along high banks the locals call the Hogsbacks. This is a tree-lined, forested drive that is often near the lake. There is less development here than anywhere else on Mille Lacs, but you'll pass some resorts, cabins, and homes. Wealthwood, a thriving settlement at the start of the twentieth century, has an old schoolhouse now used as a town hall.

Between Wealthwood and Malmo is a long stretch of sandy beach that you can access from a roadside pull-off on the highway. The shoreline is shallow, so you can roll up your pants and wade out from shore.

At Malmo, go south on Minnesota Highway 47. Here the road moves away to the lake, although if you explore the side roads, you'll find they often lead to cabins and homes along the shore. The last town you'll pass through before completing your Mille Lacs circumnavigation is Isle. Here you'll find the Mille Lacs Lake Historical Museum and some interesting shops. The museum has displays of wooden boat building and early logging, as well as a collection of Mille Lacs photographs, including dramatic shots of the tornado that crossed the lake in 1985.

The antique gas pumps at the recreated Indian Trading Post fueled travelers' vehicles in an earlier era.

The Northwest

Parklands and Glacial Lakes

Ten thousand years ago, most of Minnesota was a block of ice. During a prolonged, global cold snap, massive glaciers crept southward from the polar reaches. Inch by inch, year by year, Minnesota was covered by glaciers hundreds of feet thick.

Anyone who has spent a snowy winter in Minnesota understands how a glacier is formed. In winter, snow gradually accumulates, both in depth and density. Say there is ten inches of snow on the ground. A five-inch, fluffy snow falls on this base. A day later, the fluffy snow may have settled to just three inches, adding to a dense, naturally compacted base. In late winter, when snow depths exceed two feet, the accumulated snow may have the density of flour. This heavy snow, called a snow pack, is slow to melt in the spring.

OPPOSITE: Blazing star is among the many native prairie plants found on northwestern Minnesota's prairie preserves.

Many fine mornings of fishing begin at this boathouse on Otter Tail County's Lake Lida.

A glacier is a snow pack that doesn't melt each year. Instead it grows and becomes thicker and heavier. The heavy weight of the ice exerts tremendous pressure on earth beneath it. As the glaciers slowly move, they scour the land like monstrous pieces of coarse sandpaper, with grit formed by boulders and stones frozen in the ice.

Eventually, the climate started to warm and the glaciers slowly retreated from Minnesota. The melting waters formed lakes and rivers of a magnitude that is beyond our imagination. The greatest lake was Agassiz. Named for scientist Louis Agassiz, the lake sprawled across

the expanse of northwestern Minnesota and beyond. Its outlet was the glacial River Warren, a wide, rumbling flow draining southward through the valley of the present-day Minnesota River.

Today the flat, former bed of Lake Agassiz drains north to Hudson Bay via the Red River of the North. Lightly populated and remote, the Red River watershed is hardly a tourist mecca, yet the Red River Valley contains some of the world's most fertile farmland. Its tremendously rich soil is a natural wonder, and virtually every inch of the flat landscape has been drained and plowed. Farther away from what residents call "the Valley," a stubborn wildness persists. The northern forest forms an uneasy boundary with the prairie. Farm fields are interspersed with stands of aspen, willow brush, bogs, and grasslands. Ecologists refer to this transition area as the Aspen Parklands.

There is plenty of water in this country, but few lakes. The huge, shallow basins of the Upper and Lower Red Lakes and the mighty Lake of the Woods remain as impressive remnants of the former Lake Agassiz. Mud Lake, in the Agassiz National Wildlife Refuge, and Thief Lake, in the state wildlife area of the same name, are the only other significant basins. These lakes are undoubtedly the greatest attractions in this part of the state because of what they have in common: biological productivity. Lake of the Woods and Upper Red Lake are famous for fishing. Mud and Thief Lakes are important stopovers for migrant ducks and geese.

BELOW: While corn and soybeans dominate the agricultural landscape, Minnesota is a prominent producer of small grains.

Up on the Border

FOLLOWING THE RAINY RIVER FROM INTERNATIONAL FALLS TO WARROAD

Directions Take Minnesota Highway 11 west from International Falls. West of Baudette, follow Minnesota Highway 172 and County Road 8 to Zippel Bay State Park. Continue on Highway 11 to Warroad.

International Falls has a deserved reputation as the nation's cold spot. When you watch weather forecasts throughout the winter, the town often reports temperatures that plunge far below zero. More than one manufacturer has used International Falls as the cold-weather testing site for its products. But the Falls' frostbitten image attracts others, too—the area is one of Minnesota's most popular snowmobiling destinations. International Falls is a winter wonderland.

As the name indicates, International Falls is located on the Canadian border, which is formed by the Rainy River. At the outlet of Rainy Lake, Koochiching Falls has been harnessed with a dam to provide power for paper manufacturing. Across the river is the Ontario town of Fort Frances. If you drive east a few miles on Canada's Highway 11, you can get a tremendous view of Rainy Lake from a causeway that crosses the lake's north arm.

When you get back in the United States, go west, this time on Minnesota Highway 11. Along the way, you'll leave the pines and granite of the Canadian Shield and cross the flat plain that is the former bed of glacial Lake Agassiz. Occasional rocky outcroppings along the river, topped with tall pines, provide scenic relief in a countryside dominated by aspen forests, brush lands, and farm fields. Near the mouth of Bigfork River, stop at the Grand Mound, a state historic site. The Grand

The crushing weight of glaciers etched patterns in the rocks along the shore of Lake of the Woods at Zippel Bay State Park.

Mound, the largest Indian burial ground in the Midwest, was built about two thousand years ago by a people called the Laurel Culture. The visitor center displays artifacts.

Highway 11 closely follows the Rainy River all the way to Baudette. Ontario homes and farms dot the far riverbank. There are a handful of access sites where you can have a picnic or talk to anglers who are launching or landing their boats. The river is a popular fishing hole, and an unusual fish that anglers catch here is the lake sturgeon, which can top weights of fifty pounds.

VOYAGEURS NATIONAL PARK

YOU CAN'T SEE MUCH OF VOYAGEURS NATIONAL PARK from the road. To explore this park you need a boat, camping gear, and fishing tackle. Voyageurs covers a chain of large lakes, including Rainy, Kabetogama, Namakan, and Sand Point, which form a remote reach of the Canadian border. Virtually all travel within the park is by water. Unlike the BWCAW, motorboats are allowed. Boaters find a wondrous maze of channels and islands, with shady campsites beneath stately red pines.

These border lakes have a long human history. Archaeological records show that native people camped and fished here five thousand years ago. The Ojibwe continue to live in the area, and there is a remote reservation on the Canadian side of Lac la Croix east of the park. During the fur-trade era of the 1700s and 1800s, the lakes were part of a water highway that led westward from the Great Lakes to the vast Great Northwest. In the late 1800s, there was even a brief gold rush when prospectors found gold on islands in Rainy Lake. But the real wealth discovered here was timber. During the early 1900s, huge rafts of logs were moved across the lakes. Commercial fishermen plied the waters, too.

Today the border waters are the domain of recreational users. In the summer, you can explore the park with a rented houseboat. The fishing for walleyes and smallmouth bass is as good as you'll find anywhere in Minnesota. Snowmobiling on the lakes is enormously popular during the winter.

The park is also home to an array of northern wildlife. Wolves and river otters live here. Bald eagles nest in the tall pines, and loons teach their young how to fish in the quiet bays. Park naturalists can direct you to good areas to look for wildlife.

North of Baudette, the Rainy River empties into Lake of the Woods. This storied lake stretches 110 miles north to Kenora, Ontario. The Minnesota portion of the lake is a vast, open water basin. The state's border juts sharply northward here, forming Minnesota's familiar cowlick. At the top of the cowlick is a peninsula of land that can only

KETTLE FALLS HOTEL

ACCORDING TO LOCAL LEGEND, in 1913 Madam Nellie Bly put up the money for the construction of an, ahem, establishment where Rainy and Namakan Lakes meet at Kettle Falls on the Canadian border. Her business venture proved popular with loggers, trappers, and northwoods travelers.

In fact, the Kettle Falls Hotel's reputation as a north-country landmark eventually exceeded its ill repute. Today you can spend a weekend at Kettle Falls Hotel and not worry about what the neighbors will think. Instead, they'll be envious that they weren't able to come along.

Just getting there is an adventure. The hotel is a seventeen-mile boat ride from the end of the Ash River Trail. You can take your own boat or catch a ride with a tour craft operated by a park concessionaire.

Although the hotel was renovated during the 1980s, it retains its original character. Many guests enjoy sitting on the screened veranda or listening to the vintage nickelodeon in the barroom. Preserved for posterity is a madly tilting floor in the bar.

The hotel has four miles of hiking trails to explore. The most popular trail leads to the overlook at Kettle Falls Dam, from which you can look south into Canada—honest.

Freshwater mussels thrive in the clean waters of Lake of the Woods.

OPPOSITE: The Wright Town Hall, established in 1884, was a community gathering place for prairie settlers in Marshall County.

A 1912 postcard boldly proclaims the frontier town of International Falls to be a "City of Destiny." *Courtesy of the Minnesota Historical Society*

be reached by water, air, or driving through Manitoba. The Northwest Angle, as this peninsula is known, supports a small resort community.

Resorts and fishing also drive the economy of Baudette. Entering town you'll see a giant statue of a walleye, which pretty much says it all. Distant from any urban population centers, Baudette attracts a steady stream of visitors, who come summer and winter to go fishing.

At Zippel Bay State Park, miles of white-sand beaches wait to be explored. At the mouth of Zippel Bay, a stone jetty juts into Lake of the Woods, providing shelter for boaters who use the park's marina. Named for Wilhelm Zippel, who settled here in 1887, the park was once the site of a tiny commercial fishing village. Now it is a wild place. Listen—the creaking sound you hear is the call of sandhill cranes, which nest in the park's back country. Along the beach, you may see endangered piping plover or many other birds. On park hiking trails, look for lady's slippers and other orchids, which bloom in May and June.

Continuing west, either on Highway 11 or county roads, you travel away from the lake until you near Warroad. This small town in the middle of nowhere is perhaps best known for producing powerful high school hockey teams. Not surprisingly, the town is home to Christian Brothers, a manufacturer of hockey sticks. You can cross the border north of town and follow Canadian roads to Angle Inlet, Minnesota's northernmost community on the Northwest Angle.

ROUTE 15

North by Northwest

AGASSIZ NATIONAL WILDLIFE REFUGE AND LAKE BRONSON

Directions From Thief River Falls, drive north to Holt on Minnesota Highway 32, then go east on County Road 7 to Agassiz National Wildlife Refuge. Head back west on County Road 7 to U.S. Highway 59, which you can follow to Lake Bronson State Park.

For many Minnesotans, the state's northwestern corner seems as remote as Siberia. A transition area between the northern forest and the tallgrass prairie, the landscape is a mixture of brushy bogs, aspen parkland, and marsh. The soggy nature of this place has challenged humans since the first settlers arrived. Many believed the area had tremendous agricultural potential—if only the water could be drained away, downstream to the Red River of the North. Decades of government-financed drainage resulted in an impressive network of ditches and marginally arable land. In the 1930s, as farms failed, the State of Minnesota had to step in and bail out counties that were defaulting on ditch bonds. This tremendously expensive undertaking marked a turning point in land use. The public began to value wetlands for what they were: natural sponges that retained water and provided wildlife habitat. Wetland protection became a cornerstone of conservation policy.

An example of the change in public attitude is the sprawling Agassiz National Wildlife Refuge. By 1933, developers had spent $1 million trying to drain this area, which is located in the former bed of glacial Lake Agassiz. Their efforts were largely unsuccessful. The government began a buyout of private landowners and started managing the land for its natural commodity, wildlife. Today when you follow the auto tour through the refuge, you will encounter a tremendous diversity of

wildlife. Seventeen species of ducks and giant Canada geese are among the birds that nest here. A total of 280 bird species live in or migrate through the refuge. During the peak of the spring and fall migrations, up to 100,000 ducks and 25,000 geese are present. The refuge also has two resident packs of gray wolves and a moose herd.

A short distance to the north is another wild place, the state's Thief Lake Wildlife Management Area. This, too, is a good place to observe waterfowl and other wildlife. If you are lucky, near Grygla you may see elk, because a small herd exists in the vicinity. The area's abundant wildlife has become a selling point for tourism boosters. Thief River Falls is a national destination for birders.

Lake Bronson State Park has a mixture of prairie and aspen/oak parkland forest. The lake is actually a reservoir, created in 1936 on the south branch of Two Rivers when one of the gravel ridges—left by the receding shoreline of glacial Lake Agassiz—was dammed. (These gravel ridges are about the only relief on an otherwise level landscape.) Swimming, fishing, boating, and camping are popular park activities, although wildlife is still a main attraction. Park staff say this may be the best state park in which to see a moose. Sharptail grouse are abundant on the prairie.

Throughout this region, agriculture remains an economic cornerstone. As you move north, corn and soybean plantings give way to small grains. In the Red River watershed, farm fields are huge, often encompassing most of a section (one square mile) of land. Some farms have been in the same family since the first pioneers arrived in the late 1800s. Like their ancestors, the farmers must contend with bitterly cold winters, spring floods, and the relentless prairie wind. Despite the harsh conditions, the land holds its inhabitants like a magnet. Few northwestern Minnesota farmers would choose another way of life.

OPPOSITE TOP: From the rocky shoreline of Franz Jevne State Park, just off Minnesota Highway 11 east of Birchdale, you can look across the Rainy River to Ontario.

OPPOSITE BOTTOM: Little bluestem is a native prairie grass that grows prolifically along the former shoreline of glacial Lake Agassiz in Lake Bronson State Park.

ROUTE 16

Where the Tall Grass Grows

DETROIT LAKES, BLUESTEM PRAIRIE, AND ROLLAG

Directions — Starting in Detroit Lakes, go west on County Road 6, then turn south on County Road 5. Turn west on County Road 4, which becomes County Road 10. From County 10, go south on Minnesota Highway 32 to Rollag. Backtrack north on Highway 32 and turn onto County Road 12 going west. Take County Road 23 north to U.S. Highway 10 west, then follow signs to Buffalo River State Park and Bluestem Prairie.

Detroit Lakes boosters boast that there are more than four hundred lakes in the vicinity—a blessing for the folks living in the lakeless Red River Valley. But that's only half of the story. The Detroit Lakes area also boasts untold numbers of prairie potholes. These small swamps are like bungalows in the suburbs for nesting ducks. The shallow sloughs produce a wealth of duck delectables—aquatic plants and tiny invertebrate creatures like freshwater shrimp. Grasslands in the vicinity are used for nesting.

With its surfeit of swamps, you might say that Detroit Lakes is for the birds, and a growing number of people would agree with you. The prairie-pothole ecosystem supports a wealth of bird species, and people come to Detroit Lakes just to see them. A good place to begin a backroad adventure is by birding on the wetland-marsh trail and boardwalk just north of town. You might see ducks of several species, eastern bluebirds, or even a trumpeter swan. Great blue herons nest south of town near Dunton Locks County Park.

When you drive west from Detroit Lakes toward Moorhead, rolling countryside with lakes, potholes, and scattered woods gives way to the level monotony of sugar beet fields. This is a transition landscape, a diverse and productive ecological mix of the forest and the prairie. The

Fringed sage is found in the Bluestem Prairie Scientific and Natural Area in Clay County.

region is popular with wildlife watchers who travel here to visit several natural areas and see the unique species that inhabit them.

The most distinctive feathered resident of the area is the greater prairie chicken. This native bird was once found in vast numbers across Minnesota's prairies. However, as row-crop agriculture intensified, the chicken populations dwindled along with the prairie grasslands they inhabited. Today, a small population remains in west-central Minnesota. Like other native grouse species, prairie chickens have a grand spring mating display. In early spring, a flock will gather on the "booming grounds," where the males strut their stuff for the hens. Leaning forward, the males puff out two orange-colored air sacs along their neck. Dark, horn-like feathers stand erect over their heads. Dancing males make a booming sound, like air blown over the mouth of a bottle.

Boats fill the "parking spaces" along a marina dock on Detroit Lake.

The chickens dance each spring at the Bluestem Prairie Scientific and Natural Area, which is considered one of the best remnants of native tallgrass prairie remaining in the state. This expansive preserve is large enough to give visitors a taste of the original prairie wilderness. It is also part of a larger complex of prairie tracts that includes Buffalo River State Park and Moorhead State University Regional Science Center. The grasslands are burned periodically to mimic the natural prairie wildfires. The preserve contains uncommon wildflowers, including the western prairie fringed orchid and the small white lady's slipper.

Buffalo River State Park is a good base of operations for your prairie forays. The park offers recreational amenities, as well as something that is a prized commodity in this open country—shade. The ribbon of trees along the banks of the Buffalo River is about the only wooded area from here to Moorhead. The river is aptly named: Occasionally, bison bones are found along its banks. Like the adjacent prairie, the river bottom habitat is largely undisturbed.

Sunflowers stretch to the horizon in the northwest, where long views are the norm.

The prairie also offers an unspoiled night sky. The neighboring Moorhead State University Regional Science Center has an observatory that is used for public astronomy programs. An interpretive center on the site contains natural history exhibits highlighting the northern tallgrass prairie. Self-guided nature trails provide further opportunities to learn about the prairie ecosystem.

When you walk the wild prairie, it places the first settlers' challenges in perspective. Using oxen, mules, and draft horses, they broke the

TAMARAC NATIONAL WILDLIFE REFUGE

LOCATED NEARLY TWENTY MILES EAST OF DETROIT LAKES, Tamarac National Wildlife Refuge is a birder's watery wonderland. The refuge contains twenty-one lakes; the headwaters of the Egg, Buffalo, and Otter Tail Rivers; and several thousand marshes and wooded potholes.

The refuge's forests mark a transition from northern conifers to hardwoods. Although the prairie begins a few miles west of here, scattered pockets of big bluestem indicate that fingers of grassland once reached into the refuge. Native people prized the area for its abundance of wild rice, maple sap, fish, and wildlife. Pioneer loggers cut the original pines, but the area was mostly shunned by settlers for being too wet and unproductive to farm. You might say that cultural views came full circle when the area's natural attributes were protected and restored as a national wildlife refuge.

Several county roads cross or border the refuge, so you have ample opportunities to see birds and other wildlife. At the visitor center on County Road 26, you can get directions for the Blackbird Auto Tour. This tour begins as a one-way drive east of the visitor center and is open during the snow-free months. You are likely to see eagles, ducks, muskrats, beavers, and other critters. The drive passes Blackbird Lake, which has extensive stands of wild rice, and Pine Lake, where you can see rafts of migrant diving ducks in the fall. Trumpeter swans have been reintroduced at the refuge. You may even see a wild turkey; the refuge is on the northern fringe of their Minnesota range.

prairie ground. Farming technology improved slowly, progressing first to steam-powered implements and then to gasoline-fueled tractors. Farmers are the sort of folks who don't throw away anything that someday might be useful, so early implements have often laid in rusty repose behind the barn. Today many are being restored as working relics—direct links to Minnesota's rich farming heritage. In late summer, farm folks and collectors gather in Rollag for a threshing festival that displays a wide array of old farm implements.

ROUTE **17**

Pearls on the Prairie

OTTER TAIL COUNTY

Directions From Battle Lake, go north on Minnesota Highway 78, then east on County Road 16 to Glendalough State Park. Return to Highway 78 and go north to Otter Tail Lake. Go west on County Road 72, then take County Road 1 to Phelps. Follow County Roads 35, 41, and 108 to the entrance of Maplewood State Park. Pelican Rapids is west of the park on U.S. Highway 108. From Pelican Rapids, take Minnesota Highway 59 to County Road 3, which turns into County Road 1 and leads into Fergus Falls.

Backroads adventurers are likely to discover something that fans of Otter Tail County already know: This is a beautiful place. Rolling hills, lakes, and forests interspersed with farms create a diverse landscape.

You can begin an Otter Tail tour at Glendalough State Park north of the town of Battle Lake. Glendalough is a relatively new addition to the state park system and has minimal development. Throughout most of the twentieth century, the park was a summer retreat and game farm for owners of the *Minneapolis Tribune*. Today, folks come here to find uncrowded and unsophisticated fishing for sunfish and bass. No motors or electronic fishing gear are allowed on Annie Battle Lake.

Swing west of Otter Tail Lake to pass through Phelps, another uncrowded place. Here the attraction isn't fishing, but a flour mill that dates to 1889. You can picnic in the park by the stream.

No one would mistake the steep hills in Maplewood State Park for a mountain range, but the "peaks" here are about six hundred feet higher in elevation than the Red River Valley to the west. Hallaway Hill has the best view. The park encloses over 9,200 acres and contains numerous lakes. The largest, Lake Lida, is popular with walleye anglers. The park is a microcosm of Otter Tail County's ecological diversity. There are thirteen plant communities in Maplewood, ranging from aspen forest

One of the largest steam-threshing events in the United States, the annual Rollag Steam Threshers Reunion draws thousands of visitors from every corner of the country.

to prairie. Hikers will find twenty-five miles of trails and an abundance of wildlife. About 150 bird species breed in the park. Part of the Leaf Hills, known to geologists the Alexandria Glacial Moraine, the park has vistas of small lakes set in deep valleys. Hardwood forests composed of sugar maple, basswood, and oak glow with fall color.

The biggest bird you'll encounter is in the nearby community of Pelican Rapids, where you'll find a fifteen-foot statue of a pelican. From here jog south to Fergus Falls, a small town in appealing natural surroundings. Be sure to stroll through the historic business district and along the walkway following the Otter Tail River. An indoor attraction of note is the Otter Tail County Museum, with impressive exhibits of a native dwelling, a historic farm, and small town Main Street. The most visible residents of Fergus Falls are Canada geese. The birds nest here and are joined by thousands of their brethren in the fall. On October evenings, you can watch flocks of geese making flights between their feeding and resting areas.

In an earlier era, many Minnesotans learned to read and write in schools like this one in Otter Tail County, now abandoned on the prairie.

RIGHT: The wake-up call of a rooster is still heard on many Otter Tail County farms.

PAGES 134-135: Fishing boats wait to get wet as the sun rises over Lake Lida.

ROUTE 18

A Message from the Past?

ALEXANDRIA, LAKE CHRISTINA, AND SEVEN SISTERS PRAIRIE PRESERVE

Directions From Alexandria, head west on County Road 82 to Ashby and Lake Christina. From Ashby, follow Minnesota Highway 78 around the north side of the lake to Seven Sisters Prairie Preserve. Follow Highway 78 north to County Road 38 and turn east to reach Inspiration Peak, south of Clitherall.

It was over one hundred years ago, but the question lingers: Is the Kensington Runestone for real? In 1898, Olaf Ohman, a Swede, found a large flat stone gripped in the roots of an aspen tree he was grubbing from a field. His son saw marks cut into the rock, so the men brought it home. Further examinations revealed two inscriptions, one on the face of the stone, the other along the edge. Translated, the Norse script on the face reads:

8 Goths and 22 Norwegians on exploration journey from Vinland over the West We had camp by 2 skerries one days journey north from this stone We were and fished on day After we came home and found 10 men red with blood and dead Ave Maria Save from evil

The script along the edge is translated as:

Have 10 of our party by the sea to look after our ships 14 days journey from this island Year 1362

If authentic, the Kensington Runestone, named for the town near Ohman's farm, is proof that Viking adventurers found their way to Minnesota more than one hundred years before Columbus discovered

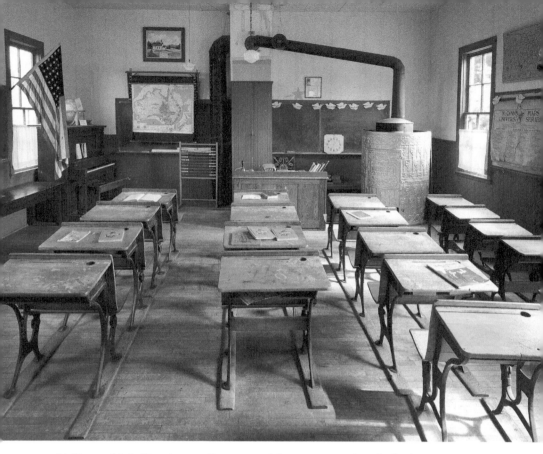

At Alexandria's Kensington Runestone Museum, wooden desks from a country school bear the scars of use by generations of schoolchildren.

the New World. Such supposition is not so far-fetched as it may first seem. The Vikings are known to have reached the New World by about 1000, as the Viking settlement excavated at L'Anse aux Meadows on the Canadian island of Newfoundland proves. But that barren, rocky coastal site is thought to be no more than a waypoint to the storied Vinland, which remains undiscovered.

Believers in the Kensington Runestone theorize that a party of Viking adventurers sailed to Hudson Bay, up the Nelson River to Lake Winnipeg, then into Minnesota along the Red River of the North. They say the "2 skerries," or rocky islands, are located in Cormorant Lake, southwest of Detroit Lakes. Three large boulders at Cormorant have triangular holes drilled in them, which believers say were made by Vikings to moor their boats. Nonbelievers say all of this is nonsense.

They point to a wave of proud Scandinavian immigrants that moved into Minnesota at the time the stone was discovered. Their theory is that the stone was a hoax intended to stir ethnic pride.

Whatever you believe, the stone is displayed at the Kensington Runestone Museum in Alexandria. If the stone is "on tour," there is a large-scale replica on the site. "Alex" as the town is known, is a good place to begin this backroads ramble. You'll know you've arrived when you see Big Ole, the twenty-eight-foot statue of a Viking and a monument to the town's boast that it is "the birthplace of America." The 1872 home of former Minnesota Governor Knute Nelson is open for tours. Surrounding the town are several well-known lakes—Ida, Mary, Le Homme Dieu, Carlos, and others.

Northwest of Alexandria on Minnesota Highway 82 you'll first drive through Brandon and then reach Ashby. The nearby lakes of Christina and Pelican are important habitat for water birds. Thousands of herons, egrets, and cormorants nest on the thirty-four-acre Egret Island in Pelican Lake. You can observe the island and its birds from a boat, but don't disturb the nesters by going to shore. Lake Christina is best known for its waterfowl. The lake was once a major migration stop for canvasback ducks. "Cans" are large diving ducks known for the sloping profile of their head and their oversized bills; drakes appear brilliantly white with a black chest and a chestnut-colored head. In autumn, you are most likely to see them flocked on Christina.

Another good place to look for ducks is from the Nature Conservancy's Seven Sisters Prairie Preserve on the north side of the lake. The "sisters" are knolls that top a hill rising two hundred feet above the lake. The hill is composed of dry soils and supports some plant species typically found west of Minnesota, as well as uncommon species such as the cancer-root, a low-growing, parasitic plant that attaches its root to a host plant.

Plan your visit to Inspiration Peak south of Clitherall on a clear day. At an elevation of about 1,750 feet, the peak rises about 300 to 400 feet above the surrounding countryside. It takes about ten or fifteen minutes to walk to the summit. There you'll find a small area of dry prairie and a heck of a view. The peak, more accurately called a glacial hill, overlooks a landscape of forests, lakes, and open country. Birders should keep an eye peeled for an uncommon prairie raptor, the Swainson's hawk.

Many Minnesota lakes support bulrushes, providing vital habitat for fish and wildlife.

A replica of Kensington Runestone, larger than the original, is located at the eastern entrance of Alexandria. The original, housed in the Runestone Museum, bears a runic inscription attributed to Viking travelers who may, or may not, have visited the area in 1362.

ABOVE: Whether or not the Vikings ever visited the Alexandria area is open to debate, but Big Ole, town mascot, stands watch over the city.

RIGHT: The Seven Sisters Prairie offers a dramatic view of Lake Christina, an important stopover for migrating waterfowl.

PAGES 144-145: Western Minnesota is defined by wide horizons.

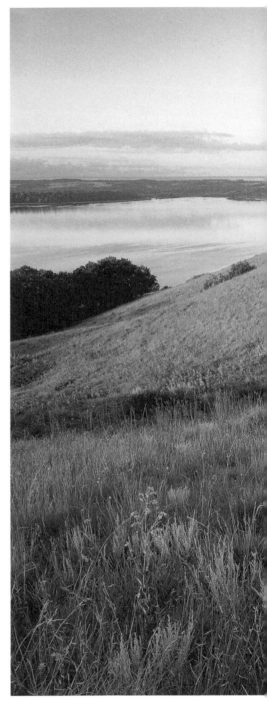

PART IV

Around the Metro and South-central Regions

WHERE RIVERS MEET

Backroads in the big city? Why not? The Minneapolis–St. Paul metropolitan area has unique topography and a mosaic of ecological communities created by the convergence of the prairie with river bottoms and the big woods. Blessed with an abundance of lakes and the junction of three major rivers, the Twin Cities have plenty of wild edges and forgotten corners.

Thankfully, state and community leaders had the foresight to protect some of the best natural areas in this region. There are several state parks, extensive county-park systems, and a number of state wildlife management areas.

OPPOSITE: A fishing boat floats on the foggy St. Croix River at Minnesota and Wisconsin's shared Interstate State Park.

The vivid colors of a Chisago County barn door are muted by a morning fog.

Within the city of Minneapolis are a series of lakes ringed with parks, and Minnehaha Falls is a city landmark. East of St. Paul, the urban jungle gives way to the wild and scenic St. Croix River Valley. Settled by Scandinavian immigrants, the valley and nearby countryside retain a vibrant cultural heritage. The Minnesota River Valley has Fort Snelling, a national wildlife refuge, and frontier history.

Wildlife thrives throughout the metro region. Gray wolves have been spotted within an hour's drive north of downtown Minneapolis, and drivers should always be on the look out for errant white-tailed deer.

Of course, backroading in the city has drawbacks. Topping the list is traffic. As the cities continue to sprawl (covering the better part of seven counties and still growing), pleasant, two-lane roads have become congested commuter thoroughfares. Plan your drives to avoid busy times. Another drawback is crowds. The city lakes and St. Croix Valley can swarm with people seeking the same thing as you.

The flipside is that in the Twin Cities you are never far from a place where you can walk in peaceful, natural surroundings. Venture down the backroads and you'll discover them.

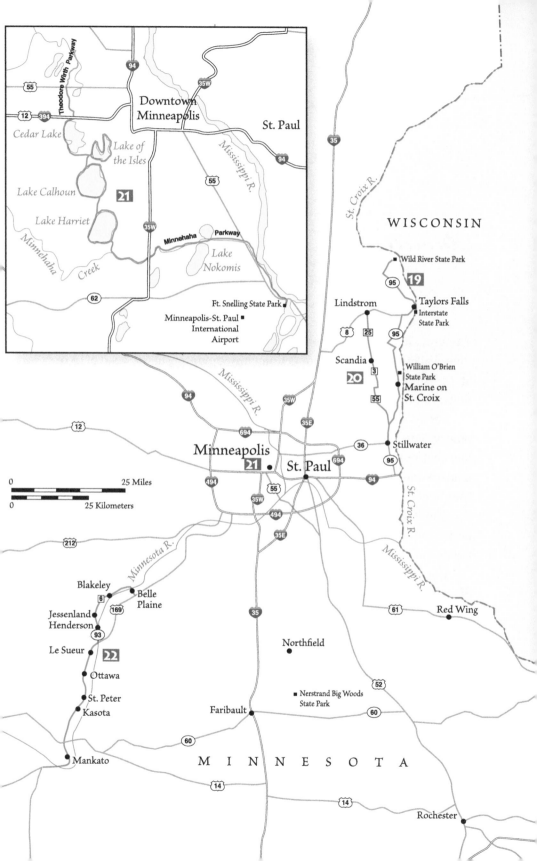

Wild and Scenic

THE ST. CROIX RIVER VALLEY

Directions From Stillwater, go north on Minnesota Highway 95 to Taylors Falls. Continue north on County Road 16 to County Road 12, which will take you to Wild River State Park.

The great Midwestern cities were built with lumber from the St. Croix River Valley. The St. Croix Boom Company, operating at the head of Lake St. Croix north of Stillwater, collected the fat pine logs that were floated down the river in massive rafts.

Today it is difficult to imagine that the valley was once a vast pinery. The pines persist along the river bluffs, near towns and farms, and scattered through the forest. Although their stately, ancient beauty lends wildness to the place, the pines are but remnants of the forest that built the Upper Midwest.

The St. Croix forms Minnesota's east-central border with Wisconsin. A nationally designated wild and scenic river, the St. Croix is a surprisingly unspoiled resource on the edge of a major metropolitan area.

Our backroads drive along this river starts on Minnesota Highway 95 in Stillwater, one of the state's oldest communities. In Stillwater, the past is still present, and today the town trades on its river heritage. The historic downtown is a busy kaleidoscope of chic shops and restaurants. Stillwater is cosmopolitan but in scenic terms—the ooze of urban sprawl stops here.

As you go north beside the river, the city slips behind. In the town Marine on St. Croix, the road nears the river. Upstream from William O'Brien State Park, the river valley becomes rocky and steep. Approaching Taylors Falls, the highway twists along the bluff tops and offers a view of the famous Dalles of the St. Croix.

In Chisago County, urban development gives way to a pastoral landscape.

This rocky gorge was created by glacial runoff. Look at a map of Minnesota and Wisconsin. Trace the St. Croix upstream to its headwaters near Solon Springs, Wisconsin. Just north of the lake where it begins are the headwaters of the famous Bois Brule River, which flows to Lake Superior. The two rivers flow in opposite directions through the bed of a glacial river that carved the Dalles.

You can explore the Dalles from Interstate State Park, which lies along both banks of the river at Taylors Falls, Minnesota, and St. Croix Falls, Wisconsin. A short walk along the Minnesota bank leads to glacial potholes, also called kettle holes, which are depressions carved

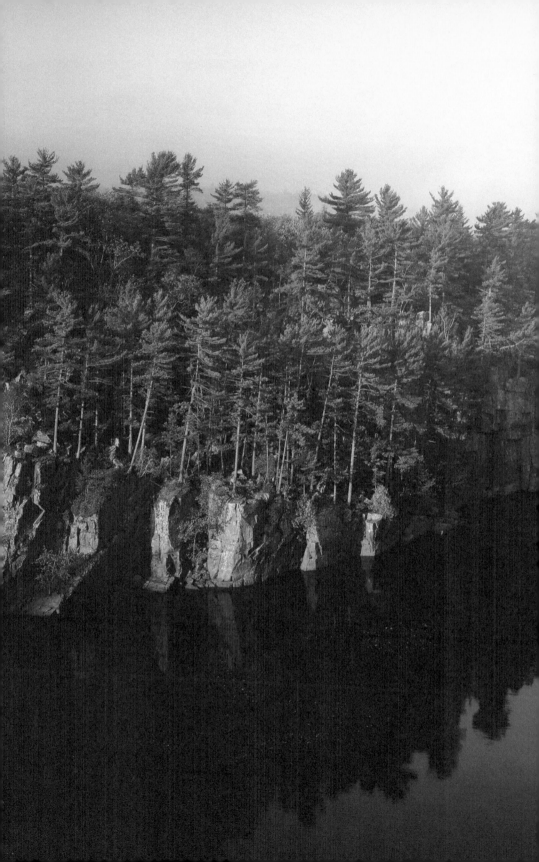

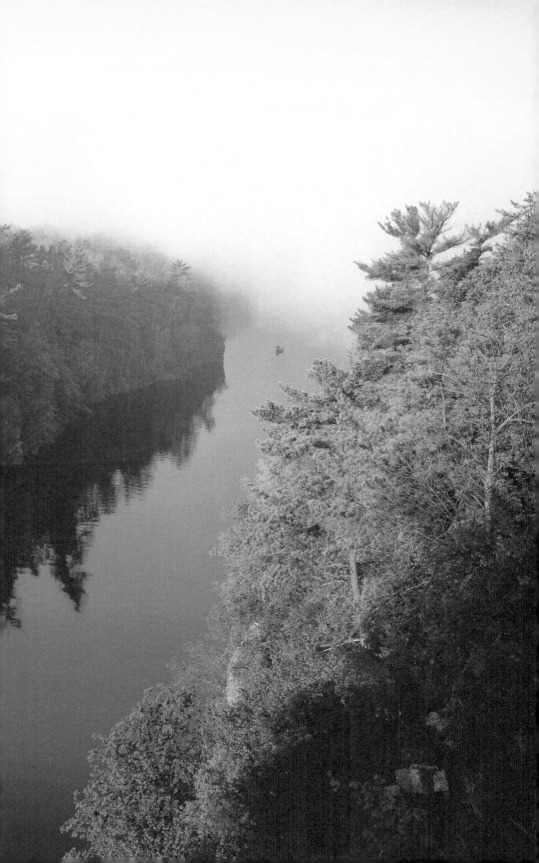

PAGES 154-155: Buildings constructed during the lumbering era now house Stillwater shops.

into the rocks by stones and pebbles swirling in the powerful glacial currents. Paddlers take canoes through the gorge, while rock climbers scale the rocky cliffs.

The town of Taylors Falls is worth a stroll. Several homes in the Angel Hill District of Taylors Falls date to the 1850s. The Folsum House is open to the public.

Wild River State Park is only lightly developed and marks the point where the river valley becomes noticeably more wild and scenic. No major roads follow the river beyond this point. The park is the first sizeable piece of wild land in the valley—big enough to provide backpacking opportunities. The park has eighteen miles of river frontage, thirty-five miles of hiking trails, and back-country campsites. The forests within Wild River State Park are a good example of the second growth, mixed hardwoods that came after logging. A short trail leads to the site of the former Nevers Dam, a massive log-crib structure that controlled the flows for river log drives. In winter, birders visit the park to look for trumpeter swans on open-water areas of the St. Croix.

PAGES 152-153: The Dalles of the St. Croix are a series of cliffs that plunge into the river downstream from Taylors Falls. Much of the St. Croix, a National Scenic Riverway, retains a wilderness quality.

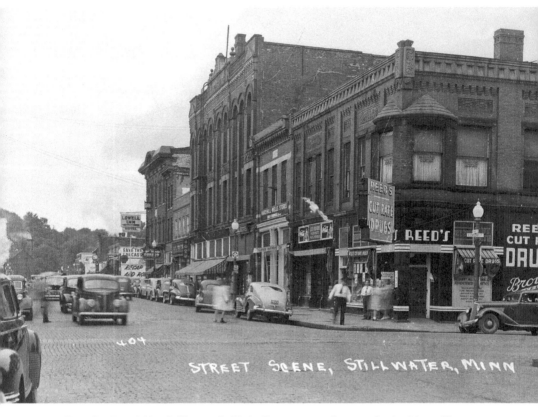

STREET SCENE, STILLWATER, MINN

Even in the 1940s, Stillwater's Main Street was often packed with traffic.

RIGHT: These two record-breaking white pine boards, photographed at a Stillwater sawmill in 1912, measured three feet wide and two and one-half inches thick. Lumber and sawmills were the foundation of early Stillwater's economy. *Photography by John Runk; courtesy of the Minnesota Historical Society*

OPPOSITE: An inviting mist shrouds a walking path in Interstate State Park along the St. Croix River.

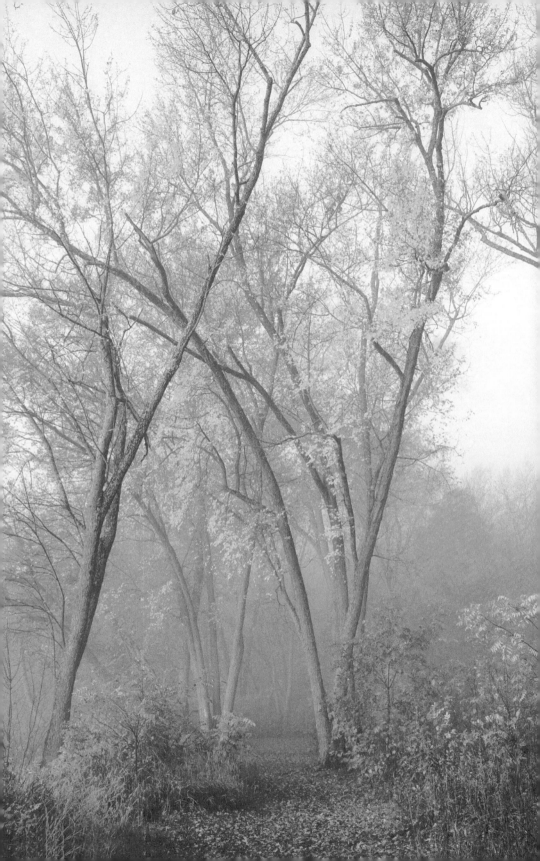

ABOVE: In Wild River State Park, you can find remnants of the great pinery that once existed in the St. Croix drainage.

LEFT: Ancient boulders in the St. Croix River Valley create a canvas for a natural mosaic.

ABOVE: A brushy fencerow is touched with frost on a crisp morning in the St. Croix River Valley.

OPPOSITE: A lone tree grows on Blast Island in Interstate State Park.

RIGHT: Minnesota's backroads are pathways through the state's history. The National Historic Folsom House in an attraction in Taylors Falls.

Little Sweden

LINDSTROM AND THE OLINDA TRAIL

Directions Starting from Lindstrom, go south on Olinda Trail (Chisago County Road 25 and Washington County Road 3) until it ends at 170th Street North (County Road 4). Go west on the latter to Norell Avenue North (County Road 55) and turn south to Stillwater.

Many places in Minnesota lay claim to a Scandinavian heritage. Nevertheless, the Swedish influence in the Chisago Lakes area is notable. During the latter half of the 1800s, the area drew Swedish immigrants who, finding the climate and landscape to their liking, settled and put down roots. Their story was chronicled by Swedish novelist Vilhelm Moberg, whose book, *The Emigrants*, has been read by countless Minnesotans.

You can find evidence of the Swedish past in the cafes and shops of communities like Lindstrom and Scandia. The homes and farm buildings built by settlers over a century ago have been preserved at Lindstrom's lakeside park, as well as at Gammelgården, a historic site on the outskirts of Lindstrom. The Swedish immigrant heritage museum here has buildings from a pioneer farmstead, including a beautifully dovetailed log house. The Hay Lake School Museum south of Scandia has a log house dating to 1868 and an 1899 brick school.

From Lindstrom, you can go south toward Stillwater along a series of county roads collectively called the Olinda Trail. The view from the road is mostly of farms and lush forests. Urban sprawl hasn't blighted the scenery. Don't be surprised to see deer or wild turkeys by the roadside.

If you make this drive in early summer, the lush greenery along the roadside is almost overwhelming. It is difficult to imagine that

The unusual Moody Round Barn has served generations of farmers in Chisago County.

two million people live with an hour's drive of the Olinda Trail. The forest is jungle-like in appearance. On rainy days, the steamy humidity is stifling.

Stop and stroll the walking paths at the Lee and Rose Warner Nature Center, which is located in an idyllic hardwood-forest setting. Inside, you'll find natural history and taxidermy displays. The center is a privately funded, not-for-profit, educational facility that provides

A full moon rises over Chisago Lakes Lutheran Church and North Center Lake.

PAGES 164-165: Much of Washington County is covered by rolling hills dotted with small lakes, which are popular refuges for city dwellers.

PAGES 166-167: Prior to settlement, Minnesota's prairies were dotted with shallow potholes.

free environmentally focused field trips for schools and offers classes on nature topics.

A good place to go for a walk in the woods (on dry days) is Pine Point Park, where there is an extensive network of bike trails. Another option is to make a detour eastward on the Square Lake Trail to the county park on the lake of the same name. Square Lake is notable for its cold, clear waters, which support trout. Brown's Creek on the north edge of Stillwater is one of a few metropolitan trout streams.

ROUTE **21**

City Parkways

THEODORE WIRTH, CEDAR LAKE, AND MINNEHAHA

A warm, spring evening is special in Minneapolis, the City of Lakes. Daylight lingers long after the dinner hour, so you can get outside and enjoy a preview of summer. The sound of a neighbor's lawnmower is music, the smell of his fresh-cut grass intoxicating. Even the occasional mosquito bite is welcome. The recently passed winter, after all, is Minnesota's longest season.

An evening such as this is perhaps the best time to drive parkways around the city lakes. Head west of downtown on Minnesota Highway 55 and turn south onto Theodore Wirth Parkway. This route may not meet anyone's definition of backroad, but it is an exquisite drive through miles of city parks. On a warm evening people are out: walking, inline skating, canoeing, fishing, and just plain people-watching.

Just south of Wirth Lake is the Eloise Butler Wildflower Garden and Bird Sanctuary, a fourteen-acre site with a one-mile trail that is well worth the walk. Across Birch Pond from the garden is a tamarack swamp called the Quaking Bog. Anyone who yearns for the north country should walk the bog boardwalk. In spring, the new needles on the trees are a vivid green. Come back in the fall when the tamaracks turn golden before their needles fall.

Next on the route are scenic Cedar Lake and Lake of the Isles. If you turn east on Lake Street, you'll go from backroad to Uptown in less than a mile. Continue on the parkway route and you'll be on Lake Calhoun. This area is the heart of Minneapolis, and the downtown skyline forms a dramatic backdrop. There is no development on Calhoun's shores, but across the parkway and down intersecting streets are rows of stately homes.

A stroll around Lake Harriet at sunrise offers a serene view of the City of Lakes.

Surprisingly, both Lake Calhoun and Lake Harriet, immediately south, are noted for challenging but rewarding fishing. Trophy-sized walleyes, largemouth bass, muskies, and pike are caught every year. Migrating waterfowl and other traveling birds, unperturbed by the urban setting, use the lakes and their immediate surroundings.

The outlet of Lake Harriet drains into Minnehaha Creek, which bisects south Minneapolis on its course from Lake Minnetonka, through Lake Nokomis, and to the Mississippi River. The route follows the creek east as Minnehaha Parkway. Entering the river valley, the creek drops abruptly off a limestone escarpment, forming the famous Minnehaha Falls.

Not far downstream from Minnehaha Falls is Fort Snelling State Park and the adjacent state historic site. The fort is strategically situated at the confluence of the Mississippi and Minnesota Rivers. Knowing the

importance of this location, Zebulon Pike negotiated a treaty with the Dakota Indians to acquire control of the land in 1805. Construction of the fort was completed in 1825—more than twenty-five years before the pioneers started to proliferate in Minnesota. The fort remained part of Minnesota's military life until the years after World War II. Located at the confluence of the Minnesota and Mississippi Rivers, the park's trails system links with trails to Minnehaha Park and the Minnesota Valley National Wildlife Refuge.

You can hear the fort's story at the historic site, but if you want to walk on the wild side, head for the river bottoms within the state park. If you can tolerate the roar of jets from the nearby international airport, the park has ample room for anglers, sunbathers, and other seekers of solitude.

Minnehaha Falls is a natural wonder in the heart of the Twin Cities.

A living floral arrangement graces a pioneer structure in Como Park.

The barracks and officers' quarters at historic Fort Snelling testify to the strong presence the military had in Minnesota in 1800s.

At Fort Snelling State Park, visitors get a glimpse of Minnesota's military life in the late 1820s. The sutler store—the nineteenth-century equivalent of the post exchange (or PX)—is one of the buildings recreated from archeological excavations and historic records.

NORTHFIELD AND NERSTRAND BIG WOODS STATE PARK

A MEETING AT A BANK IN MANKATO on Monday, September 4, 1876, changed the course of Minnesota history. Jesse James's gang of desperados saw the crowd of citizens outside the bank and decided to go elsewhere to commit a robbery. Three days later they attempted to rob the bank in Northfield and were spectacularly unsuccessful.

The gang of robbers included Frank and Jesse James, the Younger Brothers (Cole, Bob, and Jim), Clell Miller, Charlie Pitts, and William Stiles—all seasoned outlaws. During the Civil War, several rode with William Quantrill's Confederate guerillas on raids in Missouri and Kansas. In the decade after the war, the gang claimed to be taking Confederate revenge on Yankee capitalism with armed robberies and murders in the South and Midwest. The gang is credited with robbing ten banks, four trains, and two stagecoaches. They murdered fifteen people.

The raid on Northfield played like the plot from a western movie. Members of the gang rode into town at mid-morning, first loitering in front of a hardware store and then going to a local establishment for food and drink. At 2 p.m., they started for the bank. Charlie Pitts, Bob Younger, and Frank James were to make the heist. Cole Younger and Clell Miller were to guard the bank entrance. The rear guards for the getaway were Jesse James, Jim Younger, and William Stiles.

Inside the bank, things quickly went awry. Frank James shot and killed head teller Joseph Lee Heywood when he refused to open the vault. Outside the bank, an armed citizenry mustered against the robbers. Shooting a rifle from the second floor of the Dampier Hotel, Henry Wheeler killed Clell Miller. William Stiles also died on the street. A Swedish immigrant, Nicolas Gustafson, was killed by a stray bullet. The remaining six outlaws rode off from the melee badly wounded.

The injured outlaws remained undetected, even though they were only able to travel fifty miles in a week after the shootout. Then the gang split up, with the James brothers heading on horseback for South Dakota. Pitts and the three Younger brothers continued on foot.

Two weeks after the robbery, the latter four were seen by a small boy, who notified authorities. A seven-man posse crept up on the outlaws and opened fire. Pitts was killed and the Youngers seriously injured during the shootout. When they had recovered enough to stand trial, they were given life sentences at the Stillwater Penitentiary. Fear of reprisal kept the boy from publicly revealing his identity until 1929—over fifty years later.

The citizens of Northfield annually commemorate the anniversary of their clash with the James Gang with a late-summer celebration. When you visit the town, be sure to stroll through Northfield's historic downtown. Two of the state's best-known colleges, St. Olaf and Carleton, are located here.

From Northfield, head south on Minnesota Highway 246 to Nerstrand Big Woods State Park. The Big Woods was a hardwood forest that once covered much of this part of the state. It was cut down and cleared by settlers. The forest in this park is considered one of the best remnants. Today, less than ten square miles of the Big Woods remain. In spring, wildflowers such as spring beauty, the rare dwarf trout lily, and Dutchman's-breeches grace the forest floor. Fall brings a flame of color to the basswoods, maples, and other hardwoods. A hike to Hidden Falls is in order whenever you visit.

Towering maples in Nerstrand Big Woods State Park blaze with October color. The park contains a remnant of the hardwood forests that covered south-central Minnesota prior to European settlement.

Down by the River

BELLE PLAINE TO MANKATO

Directions From Belle Plaine, go south on County Road 6 to Blakeley. Cross the river on County Road 5 and go south to Henderson. From Henderson take Minnesota Highway 93 to Le Sueur. Go south of County Road 36 to Ottawa. County 36 turns into County Road 23 and leads south to St. Peter. Follow U.S. Highway 169 south from St. Peter to Mankato.

U.S. Highway 169 is a busy, four-lane highway, the primary transportation artery extending southwest from Minneapolis–St. Paul to regional hubs like Mankato. Closer to the metro, near Shakopee, the high tide of development surges along the highway corridor. It isn't until you're out around Belle Plaine that you push beyond the sprawl and the backroads begin.

Cross the river to reach Sibley County Road 6, which follows the north bank to Henderson and marks the beginning of the Minnesota River Valley Scenic Byway. From here, you are heading into history. Pioneer farmers settled the Minnesota River Valley in the mid-1800s, turning over the prairie sod to expose the rich, dark soil. Remnants of their lives are found at a surprising number of historical sites along throughout the valley.

In fact, Sibley County Road 6 is significant part of that history. The road originally was a stagecoach route that began at St. Anthony (now part of Minneapolis) and followed the Minnesota River upstream to Fort Ridgely. Traces of the original road are visible at the base of the bluffs on the west side of the county road. A stage wasn't the only way to travel up the river. Steamboats plied the currents in the 1850s, stopping at docks like the one at Walker's Landing. Today the 150-year-old community is a sand and gravel pit.

Irish settlers worshiped at the St. Thomas Catholic Church in Jessenland. True to their roots, congregations continue to worship in country churches throughout the state.

At Blakeley, you can turn east on County Road 5 and take a side trip along the Avenue of Trees to the river. The huge cottonwoods were planted in 1925 to honor World War I veterans. Back on County Road 6, the 1870 St. Thomas Catholic Church at Jessenland was built to serve some of the first Irish farmers in Minnesota. A few miles down the road is Henderson, which dates to the same era. Like the church, the brick buildings in the town's historic commercial district are on the National Register of Historic Places. You can see some of the buildings along Main Street, such as the Henderson Community Building, formerly the Sibley County Courthouse, built in 1879, and you can visit the August F. Poehler House, a brick mansion dating to 1884, which now houses the Sibley County Historical Society's museum.

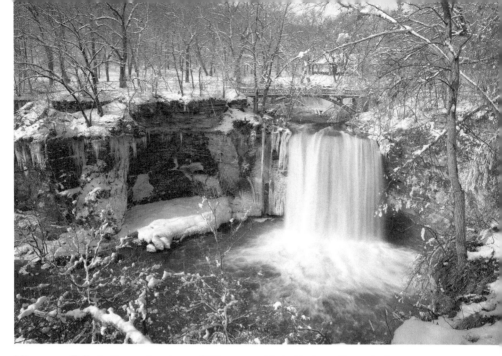

Minneopa Falls is the centerpiece of Minneopa State Park southwest of Mankato. Hiking trails lead up to and around these striking waterfalls.

South of Henderson, follow Minnesota Highway 93 south to Le Sueur. Stop and stretch at the Rush River Wayside, which is part of the Minnesota Valley recreational trail. Continuing south, you'll pass Wilkleman's Lake, where a brewery once stood. This and other lakes along the road offer opportunities to observe birds and other wetland wildlife. Look closely, and you may see the Jolly Green Giant—Le Sueur is his hometown. Another famous Le Sueur resident was Dr. William Mayo, who practiced medicine from a home he built in 1859. That home is now open for tours. Mayo and his two sons later founded the famous clinic in Rochester.

Continue south from Le Sueur on County Road 36 to the village of Ottawa, where several structures built prior to 1870 from locally quarried limestone are still standing. One of these is the quaint Ottawa Methodist Church, known as the "Little Stone Church in the Valley"; constructed in 1859, it is one of the three oldest Methodist buildings in Minnesota.

OPPOSITE: The bottomland forest along Prairie Creek in Nerstrand Big Woods State Park is one of the first places to become green in the spring.

A local Benevolent Association displays its patriotism as it stages a parade though downtown St. Peter in this 1911 photograph. *Courtesy of the Minnesota Historical Society*

South of Ottawa on County Road 23, the area's natural heritage is protected at the Ottawa Bluffs Preserve, which contains a remnant of tallgrass prairie and hardwood forest along the river bluffs.

St. Peter is a small town that looms large in Minnesota history. Founded by Captain William B. Dodd in 1853, it is one of Minnesota's oldest cities. Here, in 1851, the U.S. government and Dakota (Sioux) Indians signed a treaty that opened this part of the state to pioneer settlement. The Treaty Site History Center offers educational displays on the treaty and conflicts it generated, as well as artifacts from life in that era. Over a dozen local buildings are on the national historic register, including the 1871 Julien Cox House, built by the town's first elected mayor and now restored according to the original blueprints. Outside visitors can admire the house's Gothic-Italianate architecture; inside you can tour the rooms furnished in the best of late-Victorian style. Another St. Peter landmark, Gustavus Adolphus College, overlooks the city and the Minnesota River. The narrow, 180-foot steeple of the college's Christ Chapel towers above the trees.

Kasota, just south of St. Peter, is located on deposits of a yellow limestone called Kasota Stone, which is quarried and used in construction. The nearby Kasota Prairie Scientific and Natural Area lies on a rock terrace seventy feet above the Minnesota River and is an excellent place to view wildflowers. Bikers enjoy the thirty-nine-mile

Sakatah Singing Hills Trail, a paved path on an abandoned railroad line between Mankato and Faribault.

Where the Blue Earth River joins the Minnesota is the location of Mankato, the regional hub of south-central Minnesota. Amidst the city's bustle, you can find traces of its past. The R. D. Hubbard House, built in 1872, is the town's oldest mansion. A carriage house on the property contains a collection of horse-drawn carriages and antique autos. Local history exhibits are housed at the nearby Blue Earth County Heritage Center.

Southwest of town, the centerpiece of nearby Minneopa State Park is, surprisingly, the largest waterfall in southwestern Minnesota. The park also contains traces of a pioneer village and the Seppman Mill, a German-designed, wind-powered, stone gristmill. North of Mankato is Swan Lake, one of the largest prairie potholes in North America and the site of a large-scale habitat restoration project. Use a canoe to explore this wildlife-rich area.

A field of Indian grass leads to an oak savanna at the Nature Conservancy's Ottawa Bluffs Preserve. This thirty-acre preserve has been grazed but has never been plowed or cultivated.

PART V

The Southwest

Prairie Pathways

We don't often think of Minnesota in the context of the Old West. But the West begins on the western Minnesota prairie. During the first half of the 1800s, the vast, tallgrass prairie was a frontier. The settlers and their plows hadn't arrived. The landscape was a rich mosaic of grassland and marsh. This was Indian territory, where native people lived in rhythm with the bison. The frontiersmen who ventured on the prairie were mostly traders and trappers.

By the mid-1800s, the inexorable tide of settlers was ready to move west of the Mississippi River. Treaties were signed with the Indians, opening the prairie to pioneer settlement. By the Civil War period, the flood of new homesteaders, coupled with poor government

OPPOSITE: Where boulders of Sioux quartzite resist the plow, the prairie still thrives in southwestern Minnesota.

LEFT: In New Ulm they take their oom-pah-pahs seriously, celebrating the town's German heritage with an annual festival.

policy toward Indians, sparked a war between the pioneers and native Dakota in the Minnesota River Valley. This violent clash of cultures recurred throughout the course of westward expansion and certainly did not originate in Minnesota. Nevertheless, the 1862 Minnesota conflict marked the beginning of the end for the Dakota people. Fourteen years later, other Dakotas achieved victory at Little Bighorn, only to be ultimately defeated and placed on reservations.

If Little Crow, Mankato, and any other Dakota returned to Minnesota today, they would not recognize their prairie homeland. The prairie is considered the most ecologically altered landscape on the North American continent. The lush grasslands were plowed up so the rich, black dirt could be planted with row crops. As farming technology improved, fields became bigger to accommodate larger machinery. Pastures were plowed and wetlands were drained to make more room for growing corn and soybeans. The wild prairie disappeared.

Today the natural world has retreated to the water's edge, and a backroads traveler is wise to do the same. Seek out the lakes, the river corridors, and the sloughs, where you'll also find the wildlife areas, state parks, and small towns.

The bluff-lined Minnesota River Valley is an undiscovered gem for backroads rovers. Some river towns predate the Civil War. Indians and the U.S. Army battled along these banks. Way upstream, from Lac qui Parle to Big Stone Lake, the valley remains a remarkably wild, prairie ecosystem. Another natural wonder is the lake country along the prairie's eastern edge. At the lakes you can find sand and sunshine— the stuff of summer vacations. The Glacial Ridge is a pleasant mix of farm, forest, and blue water. In the far southwest, trees and water are rare. The landscape is open, vast, and humbling. The prairie is not wholly tamed.

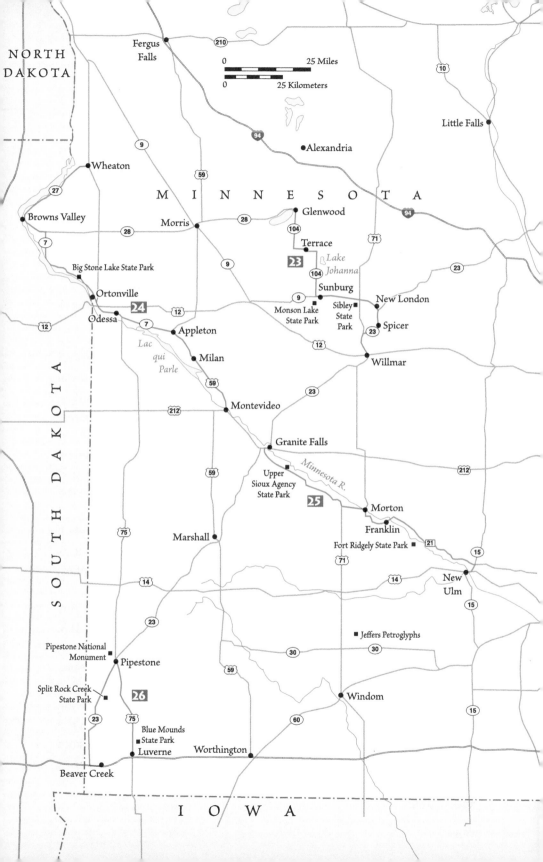

The Glacial Ridge Trail

WILLMAR TO GLENWOOD

Directions Go north from Willmar on U.S. Highway 71, then follow the signs that mark the Glacial Ridge Trail through Spicer and New London. Leaving the trail, go west on Minnesota Highway 9 to Sunburg, then north on Minnesota Highway 104 to Terrace and Glenwood.

The Glacial Ridge Trail is a mixture of two-lane blacktop and gravel roads twisting through some of west-central Minnesota's most unusual country—unusual, that is, because much of the route is hilly, wooded, and dappled with lakes, a natural island amidst an agricultural landscape. The hills have glacial origins. They mark the southward extent of the last glacier and were created from earth that was pushed up or deposited by a massive sheet of ice. Although the distance from Willmar to Glenwood isn't far as the crow flies, give yourself a full afternoon to explore the Glacial Ridge. There is more to see than you might expect.

Willmar marks the transition from the open prairie to the wooded, glacial hills. The drive north through Spicer and New London winds among lakes. The Little Crow lakes region has more than fifty lakes, many of which offer good fishing for walleyes and panfish.

If you seek a sandy beach, head for the shores of Lake Andrew in Sibley State Park west of New London, via County Road 9 and U.S. Highway 71. The high point (pardon the pun) of this park is 1,375-foot Mount Tom. The hill was used as a lookout by the Dakota people. Follow a hiking trail to its summit for a view of the surrounding countryside. The glacial hills extend in a ten- to nineteen-mile-wide band from Detroit Lakes to Willmar. The park was created through the efforts of Peter Broberg, whose family was killed during the Dakota Conflict in 1862. An eyewitness account, told by the only survivor of

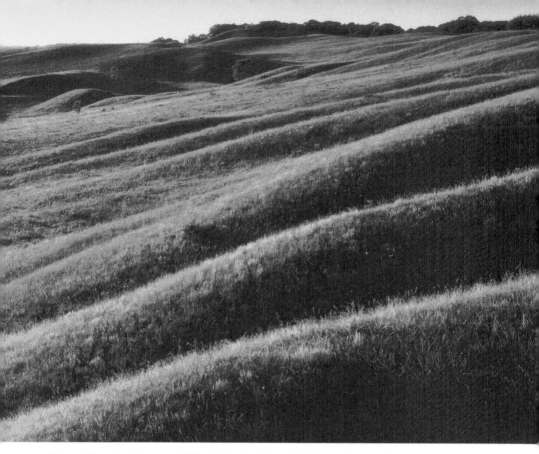

The rolling landscape of Glacial Lakes State Park was formed by glaciers that crept across the land more than ten thousand years ago. Hiking trails wind through the hills and valleys of this prairie park, alongside native grasses and wildflowers.

an 1862 Dakota attack on local settlers, including the Broberg family, is available at the park office.

If you drive through the countryside around Sunburg and Swift Falls on a glowing October evening, you'll feel as though you've entered a wildlife painting. You see the sort of marshy lakes, grassy field edges, and Minnesota farmscapes that so often form the backdrop for paintings of mallards or pheasants. You may even see a rooster pheasant standing beside the road in all his splendor.

South of Sunburg is Monson Lake State Park, which is also dedicated to the Brobergs. This out-of-the-way park is located on a small fishing lake. More prominent is Threshing Rig Alley north of Sunburg, where a local collector has lined up over a dozen machines on a high hill.

Abandoned in 1967, the Terrace Mill was saved from dilapidation by restoration efforts begun in 1979.

Birders flock to the area around Lake Johanna, north of Sunburg on Minnesota Highway 104, where a complex of wildlife areas and preserves provide habitat for wetland, prairie, and forest birds. The Nature Conservancy's Ordway Prairie Preserve, southwest of Lake Johanna, has a long history. After the first settlers were driven out by the warring Dakota in 1862, those who resettled the area built Fort Lake Johanna for protection. The site of the fort is commemorated with a historical marker. The ruts of old wagon trails to the fort can still be seen on the prairie. Located on the preserve are wetlands called calcareous fens. These boggy springs support unique plant communities.

If you enjoy wild, solitary walks, explore the nearby Little Jo Wildlife Management Area. The state-managed area contains original habitat, including a dry native prairie, a calcareous fen, some oak savanna, and remnant maple-basswood forest. The edges between these diverse cover types are attractive wildlife habitat. Old-growth oaks provide roost areas for wild turkeys and nest sites for wood ducks. You may hear male ruffed grouse drumming in the spring. Open to hunting in the fall, Little Jo is a lonely place the rest of the year.

The first dam and mill were built at Terrace on the Chippewa River in 1870. The present Terrace Mill dates to 1903 and once produced forty barrels of flour per day. The millworks were dismantled in the

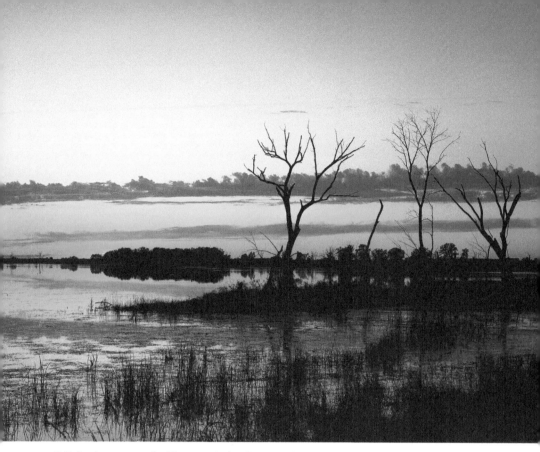

Off the beaten path, Monson Lake State Park has historical connections. The park, one of the smallest in the state, was created in 1923 as a memorial to the Broberg and Lundbergh families, most of whom were killed in the Dakota Conflict of 1862.

1950s, when the building began to be used by a church furniture manufacturer. The mill was abandoned in 1967. The old mill and other historic structures were saved by historical preservation efforts that began in 1979. Now the building houses milling equipment, as well as art exhibits and a theater. Just north of the mill is the Keystone Arch Bridge, a wonderful stone structure built by miller J. M. Danials in 1903. The dam that serves the mill has a head race and tail race system. A settler's log cabin and a fieldstone miller's home round out the display of historic structures.

From Terrace, it isn't far to Glenwood, a small prairie town beside Lake Minnewaska. The public gardens on the west side of town near the lake are eminently "strollable."

Reminders of the past, such as this country schoolhouse, spring up occasionally on prairie backroads. Many of the relics are now being utilized as town halls.

The pink lady's slipper is Minnesota's state flower.

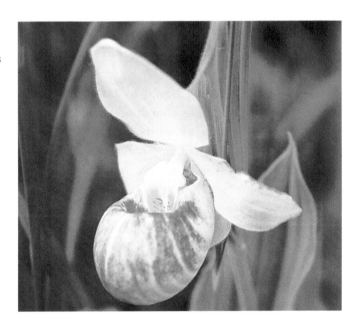

Wildlife on the Western Prairie

WHEATON, MONTEVIDEO, AND
THE UPPER MINNESOTA RIVER VALLEY

Directions Minnesota Highway 27 goes southwest from Wheaton to Browns Valley. Follow Minnesota Highways 7 and 28 southeast to Big Stone Lake State Park, then along the lake to Ortonville, Odessa, Appleton, Milan, and Montevideo.

Wheaton is located at the northern edge of a cartographic bump that protrudes into South Dakota along Minnesota's relatively straight western border. The bump is a mark of geographic distinction—a crescent created by two headwater lakes, one flowing north, the other south. Lake Traverse, from an elevation 976 feet above sea level, feeds the Bois des Sioux River, headwater tributary of the Red River of the North. Big Stone Lake, elevation 966 feet, forms the Minnesota River, which flows 330 miles across the southern half of the state to meet the Mississippi at the Twin Cities. The two lakes mark the outlet of glacial Lake Agassiz at its highest level, where the mighty glacial River Warren rumbled southward to carve what is now the valley of the Minnesota River. Agassiz receded and eventually drained north, leaving the River Warren outlet to define the slight height of land, or divide, between two huge watersheds. Driving southwest on Minnesota Highway 27 along Lake Traverse to Browns Valley, it is appropriate to contemplate the River Warren, for the ancient torrent shaped the present landscape.

Browns Valley is the beginning of the Minnesota River Valley Scenic Byway, a route rich in history and natural wonder. You might say Browns Valley Man is a little of both: A half-mile east of town is a wayside tribute to the nine-thousand-year-old skeleton, discovered

The grassy slopes of the Bonanza Prairie rise up from Big Stone Lake and are preserved in a state park that bears the lake's name.

here in 1933. Some say the Vikings passed through here, too. At Big Stone Lake State Park, it is easy to understand why people have been drawn to this place for a long time. The minimally developed, northern Bonanza unit contains an area of glacial till hill prairie preserved as a state scientific and natural area. The Meadowbrook unit has a campground and other amenities. In spring, anglers make pilgrimages to thirty-mile-long Big Stone Lake to fish for walleyes.

To get acquainted with the many backroads and wealth of wild land between Ortonville and Montevideo, plan to spend a couple of days. Pitch a tent at Big Stone or Lac qui Parle State Parks. Then grab your binoculars and go explore the valley. Some of the best wildlife viewing in the state is available here. Spring and fall are the best times to drive the four-mile auto tour through the ten-thousand-acre Big Stone National Wildlife Refuge, just outside of Ortonville. The refuge is a major stopover for migrating waterfowl and other birds.

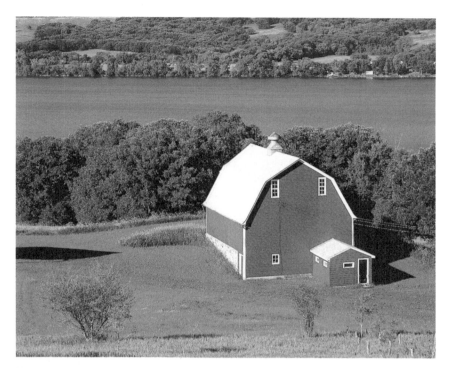

The prairie's farming heritage is evident in well-preserved barns, such as this one on the shore of Big Stone Lake.

More than 230 species of birds have been seen here, including snowy egrets, Swainson's hawks, short-eared owls, and loggerhead shrikes. On a hiking trail through granite outcrops, you'll find prickly pear and mamillaria cactus.

Big Stone is part of a larger complex of wildlife lands that includes prairie and wetland tracts owned by the state and conservation organizations. The Plover Prairie and Chippewa Prairie Preserves are remnants of the grasslands that once defined the landscape. The Chippewa Prairie was never plowed because of its rocky, rugged terrain. Indian grass, big bluestem, and little bluestem—native prairie grasses— grow in rich, loam soil. Two uncommon prairie plants, the small white lady's slipper and slender milk vetch, also grow on this preserve.

In the fall, hunters gather at Marsh Lake and the nearby, 31,000-acre Lac qui Parle Wildlife Management Area, where thousands of Canada geese, mallards, and other migrating waterfowl gather.

Lac qui Parle State Park is frequented by campers who come to fish for walleye and northern pike.

Over 100,000 Canada geese may be seen at Lac qui Parle during the peak of migration. Also look for golden plovers, tundra swans, and sandhill cranes. The Lac qui Parle area offers excellent wildlife viewing throughout other times of the year, too. There is a large nesting colony of white pelicans. Native prairie chickens have been reintroduced to the wildlife management area's vast uplands. If you have the time, make a detour to the Salt Lake Wildlife Management Area west of Madison on the South Dakota border. This is Minnesota's only alkaline wetland and a tremendous location for birding. Look for shorebirds such as willets, piping plover, and American avocets. The sweeping prairie scenery alone is worth the visit to Salt Lake.

The rich, natural wealth of the Upper Minnesota River Valley has attracted people to this region since prehistoric times. Archaeologists have uncovered remains of Indian camps and settlements, although the

The Big Stone National Wildlife Refuge preserves more than eleven thousand acres of low woodlands, wetlands, granite outcroppings, and native tallgrass prairie along the upper Minnesota River. Hiking trails, a visitors center, and a five-mile interpretive drive introduce visitors to the river ecosystem.

pioneer past is better preserved and documented. In 1826, at a time when bison, elk, and wolves still roamed the prairie, Joseph Renville established a fur trading post near what is now the town of Watson. The first Protestant mission in Minnesota was located nearby on the shores of Lac qui Parle; the site, on County Road 13, is marked with a plaque. Settlers arrived in carts and wagons pulled by oxen. The ruts left by wagon wheels are visible northeast of Dawson along the Red River Trails near the Ten Mile Creek Crossing. This route was a highway first for native people and then for settlers and the military. Nearby is the Lac qui Parle Village, which was the county's largest community in the 1870s. Visit the cemetery a half-mile west of the village to see where the early settlers are buried.

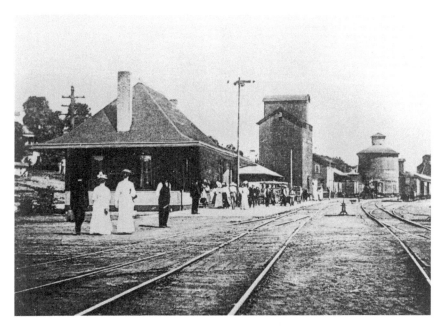

Rail transportation allowed western Minnesota farm commodities to reach distant markets quickly. This photo shows Montevideo's Milwaukee Road depot and grain elevators in 1900. *Courtesy of the Minnesota Historical Society*

Montevideo, or "Monte" as the locals call it, has emerged in recent years as a tourist center serving Lac qui Parle adventurers. Don't expect Wisconsin Dells on the prairie. Instead you'll find a pleasant, small town steeped in history. Montevideo's classic Chicago, Milwaukee, and St. Paul Depot is on the National Register of Historic Places. Be sure to visit Chippewa City, which re-creates the prairie past. This historical village was begun in 1965 and contains a collection of two dozen old buildings that have been moved to the site. You'll find all the businesses and public buildings associated with a pioneer community, including a blacksmith shop, a harness shop, and a 1911 schoolhouse. Inside the buildings are period furnishings and equipment. Of particular interest are a canoe believed to have been made prior to 1850, an 1870s log cabin, and a fully restored 1914 Seagraves Fire Engine.

Twelve miles southeast of Montevideo (via Minnesota Highway 7 and County Road 6) is the Olof Swensson Farm Museum, a restored Scandinavian farmstead dating to 1901. The farmhouse is not your

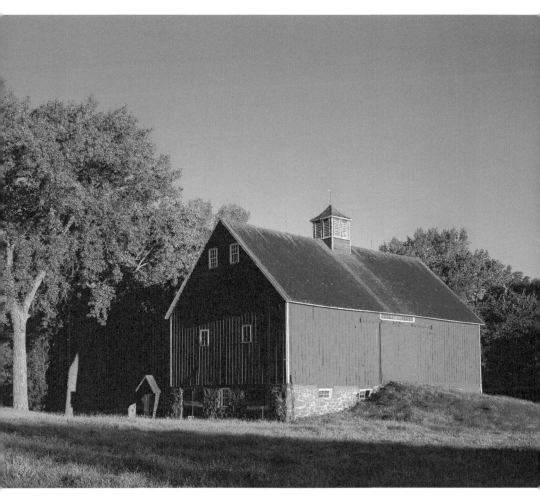

The historic double-ramp barn at the Olof Swensson Farm southwest of Montevideo dates to the 1890s. The farm, located in rural Chippewa County, is open for tours during specific summer hours and is operated by the Chippewa City Pioneer Village in Montevideo.

typical little house on the prairie, but is a twenty-two-room brick home complete with a second floor chapel.

A mile and one-half west of Montevideo is the Camp Release State Monument, erected in 1894 to commemorate the release of 269 captives taken by the Dakota during the 1862 conflict. The Dakota surrendered at Camp Release, ending the short but bloody war.

Lac qui Parle is an outstanding wild resource. Thousands of Canada geese visit the lake during spring and fall migrations.

ABOVE (BOTH): The Chippewa City Pioneer Village is home to more than twenty historic buildings and hundreds of historical artifacts, which have been contributed by the descendants of early settlers.

ROUTE **25**

The Battle Ground

GRANITE FALLS, NEW ULM, AND
THE LOWER MINNESOTA RIVER VALLEY

Directions From Granite Falls, go east on Minnesota Highway 67. Cross the river below the Upper Sioux Agency and continue east on County Road 15. At Morton, make a detour on U.S. Highway 71 to visit Birch Coulee Battlefield and the Lower Sioux Agency. Continue east on County Road 2, crossing the river again on County Road 11 to Franklin. Follow County Road 5 southeast to Fort Ridgely. County Road 21 leads to New Ulm.

Out on the prairie, place names like Granite Falls, Redwood Falls, or Hanley Falls seem incongruous. When you think of waterfalls in Minnesota, the tumbling cataracts of the North Shore generally come to mind. In western Minnesota, waterfalls are associated with the great river valley carved by glacial River Warren and now occupied by the Minnesota River. Tributaries such as the Redwood River trace a tumultuous path over falls and through gorges as they make the final descent down the rocky terraces of the glacial river valley to the Minnesota.

Granite Falls, where this backroads journey begins, is named for the only falls on the Minnesota itself. Dams were constructed on the falls to produce power. From here to its confluence with the Mississippi, the river flows free of dams. The Minnesota has retained its wild character, but not its ecological health. Pollution from agricultural runoff and inadequate sewage treatment destroyed the river's water quality. In recent years, improving the river's health has been the focus of conservation efforts. Considering the amount of agricultural development in the watershed, cleaning up the Minnesota is a daunting undertaking.

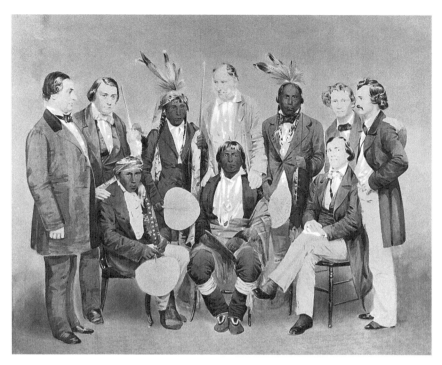

In 1858, a Dakota treaty delegation traveled to Washington, D.C. The man standing on the left is Joseph Brown. Seated on the left is Chief Mankato. *Courtesy of the Minnesota Historical Society*

This stretch of the river has a painful past that is commemorated at historical sites along the Minnesota River Valley Scenic Byway between Granite Falls and New Ulm. In 1862, the local Dakota people, hungry from crop failure and resentful of the continuous encroachment of settlers, lashed out in a late summer uprising. A series of raids and battles led to the eventual defeat of the Dakota at Wood Lake, south of Granite Falls, on September 23, 1862. A monument erected in 1919 honors those who died in the battle. The war still echoes through the valley.

A good place to begin learning about this violent time in Minnesota's history is at Upper Sioux Agency State Park. Only one of the agency's original buildings remains, but the foundations of other structures are visible. The agency was established in 1853, not long after the Dakota had signed away most of their land in an 1851 treaty with the U.S. government and became confined to a reservation that followed the

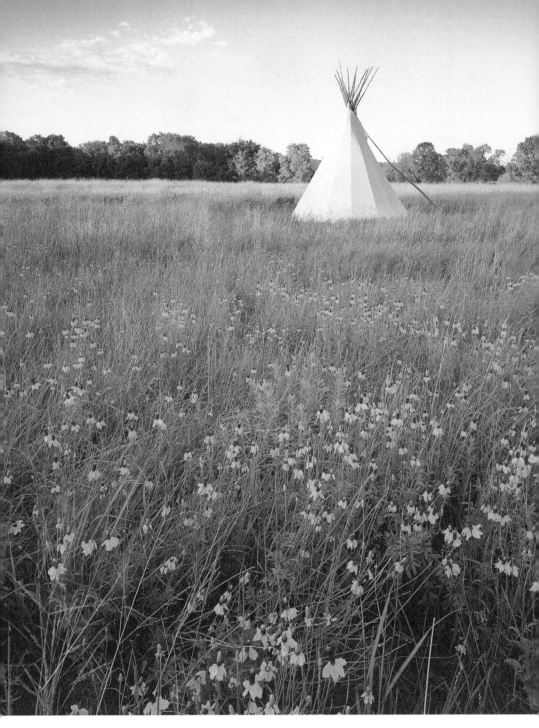

Visitors at Upper Sioux Agency State Park can camp in replicas of Dakota teepees while learning about the Dakota uprising that destroyed the original Upper Sioux Agency in 1862.

The soldiers at Fort Ridgely held off attacking Dakota for a week until reinforcements arrived from Fort Snelling. All that remains of the fort, built in 1853, are a number of stone foundations, which are now the heart of Fort Ridgely State Park.

PAGES 204-205: Minnesota is among the nation's most bountiful corn-producing states.

river valley from Fort Ridgely upstream to the South Dakota border. The purpose of this agency, and the Lower Sioux Agency thirty miles downstream at Morton, was to convert the Dakota from their nomadic, hunting lifestyle into a sedentary life of farming.

Not all of the Indian agents federally appointed to work with the Dakota were suited to the task. Arrogance, insensitivity, and condescension were too often the traits of men who worked as Indian agents. A notable exception was Joseph R. Brown, who served as the agent for the Upper Sioux Agency from 1857 to 1861. Some speculate that if he'd remained Indian agent, the Dakota Conflict may not have occurred. Brown had come to Minnesota in 1819 as a thirteen-year-old drummer boy with the troops that built Fort Snelling. When he left the army in 1825, he began trading with the Dakota people as an

The crumbling walls of the Joseph R. Brown House recall the pioneer era.

A pile of old bricks is all that remains of the Upper Sioux Indian Agency.

The ornate Brown County Museum in New Ulm was built as a post office in 1909.

Soft light inside a rural town hall invites one to escape the winter's chill.

The Harkin Store contains merchandise that was left sitting on the shelf when it closed its doors over a century ago. Located on the Minnesota River, the store once served riverboats and settlers. It now serves the public as a museum.

independent trader with Henry Sibley's American Fur Company. As a trader, he was stationed at remote posts along the upper Minnesota River and doubtless became familiar with the Dakota culture. His wife, who he married at Lake Traverse, was of French-Canadian, Scotch, and Dakota descent.

Brown looms large in Minnesota's formative state history and early politics. In the 1840s, prior to statehood, he platted the town of Dakota along the St. Croix River. Today it is called Stillwater. Later, he platted the Minnesota River town of Henderson and published a newspaper there. In 1849, he served on the first central committee for

the Democratic Party in Minnesota. He served in both the state House of Representatives and Senate, and he was instrumental in drafting the state constitution. He was also the editor of the *Minnesota Pioneer* newspaper. After helping Henry Sibley get elected governor, he was awarded the Indian agent position.

Brown encouraged some of the Indians to take up farming and traveled with a delegation of Dakotas to Washington, D.C. in 1858. After losing the Indian agency position, he remained in the area and built a house on the north bank of the river. The three-and-a-half story, nineteen-room home was built of brick and locally quarried granite—an elegant contrast to the sod and log huts that typified frontier homes, such as the nearby Rudi Memorial. Unfortunately, the Indian conflict began shortly after the home was completed. It was destroyed by fire, along with most of Brown's possessions. A wayside plaque along Renville County Road 15 marks the home's location.

Brown lost his belongings, but his family escaped alive. Others weren't so lucky. The Schwandt Memorial was erected in 1915 in memory of a pioneer couple killed during the conflict. Minnesota's best-known battlefield is located at Birch Coulee County Park along U.S. Highway 71 north of Morton. Here the Dakota chiefs Mankato and Big Eagle surrounded and engaged about 150 U.S. soldiers in a battle that lasted for a day and a half. Both sides suffered casualties. The Dakota were eventually driven off by troop reinforcements from Fort Ridgely. Although the Dakota were heartened by this battle, within weeks they were forced into retreat at Wood Lake, where Mankato was killed. They subsequently surrendered at Camp Release.

The Lower Sioux Agency historic site is two miles south of Morton on Redwood County Road 2. This is where the Dakota Conflict began in August 1862. At a time when the Dakota were desperate from hunger and angrily frustrated with their poor treatment by the government, the murder of five settlers by four young Dakotas touched off a war. Led by Little Crow, the Dakota attacked the Lower Sioux Agency, killing twenty men and taking ten women and children as captives. Indian agent Andrew Myrick was found dead, his mouth stuffed with grass. Not long before, he had refused to give food to some starving Indians, telling them to eat grass. No Joseph Brown, Myrick has become an inglorious footnote in Minnesota history.

Two prairie natives, the button blazing star and monarch butterfly, can be found in the natural setting of Fort Ridgely State Park.

Fort Ridgely State Park is one of Minnesota's historical treasures. After the Dakota overwhelmed the Lower Sioux Agency, they attacked Fort Ridgely where they were held off by troops for a week until additional soldiers arrived from Fort Snelling. The park contains the excavated ruins of the fort, which was built in 1853. The state acquired the site as a monument in 1896. The park has several miles of hiking trails with views and steep terrain. A wealth of historic information is available at the interpretative center.

New Ulm unabashedly boasts its German heritage. The town's most prominent landmark is the forty-five-foot Glockenspiel, a German clock tower with animated figures that move when the bells strike the hour. In New Ulm are an 1860 brewery, Governor John Lind's 1887 mansion, and the historic home of children's author Wanda Gag. You can find shops selling German crafts. The Harkin Store, located several miles out of town, is a state historic site stocked with merchandise from when the store closed in 1901.

ROUTE 26

Big Skies and Bison

PIPESTONE NATIONAL MONUMENT
AND BLUE MOUNDS STATE PARK

Directions From Beaver Creek, take Minnesota Highway 23 north to Pipestone. Follow U.S. Highway 75 south to Luverne, then County Road 20 east to Blue Mounds State Park.

The biggest skies in Minnesota are in the far southwest. Minnesota Highway 23 pitches and rolls as it crosses the prairie, offering sweeping views of an undulating, open landscape. Some magnetism, maybe a lingering pioneer spirit, pulls the eye to the western horizon. Even the creeks and rivers drain westward to the Missouri River.

Once there were bison here. Shaggy herds roamed a vast grassland, accompanied by prairie wolves and nomadic native people. There were antelope, too, and elk and even grizzly bears—all creatures we now consider denizens of the far-off Rocky Mountain West. But they were here before the arrival of the plow.

Now it is difficult to imagine such prairie wilderness. Most of the natural grasslands were plowed up long ago and converted to agricultural ground. Row crops thrive in the black prairie dirt. But places remain that have resisted the farmer's plow. Prairie grasses still grow in impossibly rocky pastures along U.S. Highway 75. And, at Pipestone National Monument and Blue Mound State Park, we can glimpse the land where the bison roamed.

Long narrow trenches slice the prairie at Pipestone National Monument. These ancient quarries were made by native people digging for the soft red rock they used to make pipes. A layer of pipestone a few inches thick lies just a few feet below the surface, covered by a layer of

JEFFERS PETROGLYPHS

A one-hour detour eastward on Minnesota Highway 30 from Pipestone will lead you to the Jeffers Petroglyphs historic site north of Windom. Researchers believe that native people used stone tools to chisel figures into the rock outcropping here over a five-thousand-year period from 3,000 b.c. to a.d. 1750. In addition to human figures, you'll find the shapes of animals such as bison, elk, deer, and turtles. Some folks like to speculate as to why Minnesota's early inhabitants went to so much trouble to portray these images of their world. Was it to appease their gods? Were they seeking magic for a successful hunt? Did the animals hold some special, spiritual significance? We cannot answer these questions. All we know is that thousands of years ago, people walked this ground. Figures scratched in the rock are about all that remain of their passing. We can surmise from these etchings that they appreciated the beauty and wonder of their primal world. In that respect, Minnesotans haven't changed.

In a prairie rock outcropping, ancient peoples carved symbols that are preserved at the Jeffers Petroglyphs historic site.

Pipestone Creek meanders through Pipestone National Monument, where native people quarried a soft stone called catlinite and carved it into pipes, jewelry, and other pieces of art. The quarry dates back to a.d. 900.

Sioux quartzite. Called catlinite, the stone was carved into ceremonial pipes and traded extensively among the Great Plains tribes.

Native people still come here to quarry the stone, generally in the late summer and fall when the trenches are most likely to be dry. Their exclusive right to quarry the pipestone is protected by a federal law passed when the site became a national monument in 1937. It is humbling to consider how much has changed around the quarry site during the past two hundred years, yet the significance of pipestone to the Great Plains native culture remains the same.

Pipestone is a special place. The natives call it sacred. You can follow a path from the visitor center along a small, surprisingly clear creek to an oasis of trees where the creek tumbles over an escarpment. The charms of this natural rock garden and waterfall were apparent to early explorers. In 1838, a mapping expedition led by Joseph Nicollet and John C. Fremont camped here. The explorers were struck by the beauty of their shady retreat. Members of the party carved their initials in a soft stone near the waterfall. Look for the Oracle, a rock naturally shaped like a face.

As you follow the path from the waterfall back to the visitor center, pause and look at the grass. You'll find a botanical world at your feet. Pipestone National Monument contains a wide array of native prairie vegetation—once-common species that mostly disappeared when the

The Sioux quartzite cliffs at Blue Mounds State Park extend for over one mile and are nearly one hundred feet high. Appearing blue against the horizon, the mounds were named by westbound settlers in the mid-1860s.

prairie was converted to furrowed rows. Managers periodically burn this site to mimic the prairie fires that once crossed the landscape. Fire is beneficial to grassland vegetation, which grows anew after the fire is out.

The other piece of public prairie along this route is Blue Mounds State Park, perched on a high, rocky ridge above Luverne. The park is home to about four dozen bison living in fenced enclosures. Hiking trails course the prairie around the bison grazing areas. This is a good place to see these majestic animals in a natural setting. The park derives its name from the lichen-encrusted hunks of Sioux quartzite that rise from the prairie like warts on a toad. On the south side of the park, where a rocky hill rises, mountain-like, above Luverne, the quartzite was quarried for building stone in the 1880s. A walking trail leads up the ridge to Eagle Rock, three hundred feet above Luverne. The trail offers a surprising vista: You can see all the way to Iowa and South Dakota. If you sit down, be careful. Prickly pear cactus is abundant on the ridge.

Also on this route, along Highway 23, you'll find Split Rock Creek State Park—not to be confused with the famous lighthouse in northeast Minnesota (see Part 1). This park provides a place to camp, swim, and fish in a part of the state that has limited public recreational areas. Split Rock Creek State Park contains a small impoundment, a sizeable grove of trees, and amenities such as walking trails and picnic tables. You may see migrating waterfowl and other birds using the lake in spring and fall.

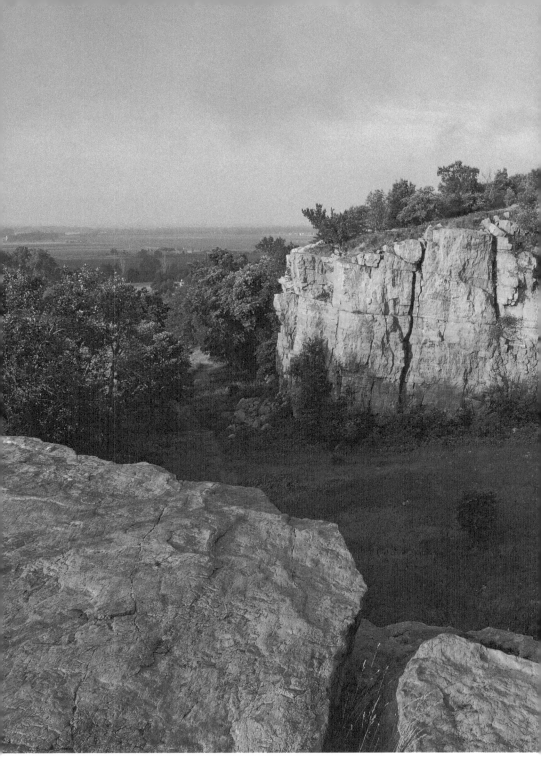

Outcroppings of Sioux quartzite dot the prairie at Blue Mounds State Park.

PART VI

The Southeast

BLUFFS AND VALLEYS

W hile the glaciers scoured and flattened northwestern Minnesota, in the state's opposite corner, the reverse is true. Southeastern Minnesota is the Driftless Region, the only place in the state that completely escaped glaciation. Bounded to the east by the Mississippi River, the southeast is essentially a plateau where tributary streams have carved deep valleys through the underlying limestone. Some of the precipitation that falls here as rain or snow percolates through the porous rock, forming underground streams and bubbling back to the surface in clear, cold springs.

There is one metropolitan area in this region: Rochester, with its world-renowned Mayo Clinic, is a quiet city built along the upper Zumbro River on the western edge of the bluff country.

OPPOSITE: A tall oak overlooking the river bluffs is a fine place to hang a tire swing.

Locally quarried limestone was used to form the foundation of this Wabasha County barn.

In winter, thousands of Canada geese gather on the ice-free waters of Silver Lake in a city park. Every morning, V-shaped flocks of the beautiful birds grace the skies over Rochester as they fly out to surrounding farm fields to feed. Like the geese, the human residents of Rochester don't have to travel far to reach the country. Beyond the city limits is a quaint, rural landscape.

The routes in this chapter barely scratch the surface of southeastern backroads waiting to be explored. Country lanes course the rolling uplands, while narrow, winding roads twist through the valleys and hollows. Although the bluff country is drawing increasing attention from wealthy urbanites who are buying up the beautiful places and building second homes, the venerable farmsteads and big red barns remain the defining architecture. In the tiny, valley towns, some brick buildings date to the 1800s. Perhaps more than anywhere else in Minnesota, the southeast has retained the character of its rural heritage and not succumbed to the generic strip-mall and tract-home development that blights so many communities.

Another bluff country asset is its wealth of public forests. The Richard Dorer Memorial State Forest extends from Hastings to the Iowa border. Dorer was a visionary conservationist with the Minnesota Department of Conservation who led efforts to reforest badly eroded hillsides during the 1940s. In the southeast, the trees grow primarily in

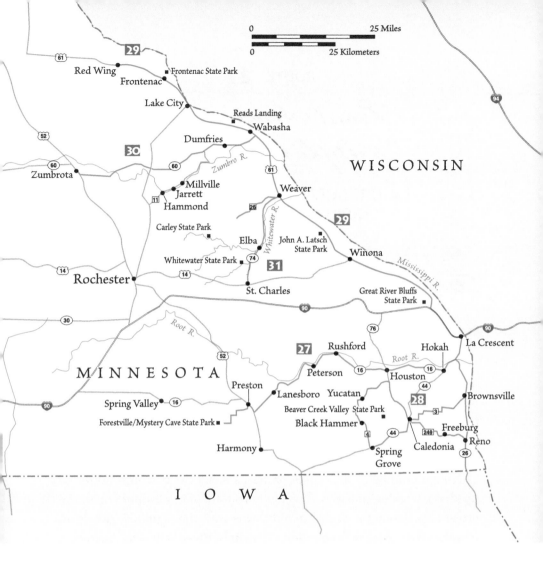

places that are too steep to plow, providing shade, wildlife habitat, and a first-line defense against erosion. Most of the trees are hardwoods, although white pine also grows here; cedars and juniper cling to the steepest slopes. In the spring, a beautiful array of wildflowers carpet the forest floor. Following warm May rains, Minnesota's favorite fungus—the morel mushroom—emerges from the duff. Mushroom pickers roam the forest then, looking for the telltale sponge-like caps of morels poking through the leaves. Sautéed in butter, morels have a simply exquisite flavor. So good, in fact, that a mushroom hunt is reason enough to explore the driftless backroads.

ROUTE **27**

Trout Streams and Apple Blossoms

LA CRESCENT, LANESBORO, AND HISTORIC FORESTVILLE

Directions Go west from La Crescent on Minnesota Highway 16. At Preston, follow County Road 12 west to Forestville/Mystery Cave State Park.

Minnesota Highway 16 is like driving through a postcard. Following the Root River Valley upstream from the Mississippi River at La Crescent, the highway passes through farmland and woods that are tidy, verdant, and oh so American Gothic. The Root River is the primary driftless area drainage, and it has etched a scenic course through the bluff country. There are crop fields and apple orchards along the bottoms, bordered by steep, wooded hillsides. Creamy limestone palisades punctuate the green hills. Along the river are old towns with the dignified, run-down elegance that some people call hip. The Root River Valley has become a refuge for artists and urban émigrés. For better or worse, you can find cappuccino here—but only if you look for it.

Traveling from La Crescent to Spring Valley, on the western edge of the bluff country, takes less than two hours of driving time, but you'd best allow a whole day or, better yet, a weekend to take it all in. Every side road heading up a valley leads to an interesting somewhere.

At Hokah, you can see Minnesota's other Mount Tom, not to be confused with the Mount Tom in Sibley State Park on the Glacial Ridge Trail in southwest Minnesota (see Part 5). This Mount Tom is a river bluff local boosters describe as "the most geologically complete elevation in Minnesota." Hokah has long been home to Winnebago Indians. A natural park in Houston contains an excellent collection of

Waning sunlight illuminates headstones and windows at the Union Prairie Lutheran Church in rural Lanesboro.

wetland and prairie plants. Rushford, with its Victorian architecture, is worthy of a midday stroll. Continuing west toward Peterson, the Root River Valley narrows and becomes more wooded. Driving toward Lanesboro, in places the sparkling river is right beside the highway. You may see anglers fly-casting for trout.

Lanesboro, like Ely in the north, is a renaissance town. It is a place where scenery and atmosphere create an "artistic ambience." You can wander the downtown, where country traditions and urban trends merge in quaint storefronts. For a breath of fresh air, explore the paved Root River State Trail. Built on an old railroad bed along the riverbank, the trail links the river towns and provides a back-forty look at the bluff lands. Biking the trail is extraordinarily popular. A city park on the west edge of Lanesboro has camping and a trout pond. Water spilling over

Much of the historic Main Street district of Lanesboro has been restored and now serves as a focal point for visiting tourists.

the dam on the Root River is especially scenic in morning light. You can see lots of trout at the state fish hatchery, just west of Lanesboro on Minnesota Highway 16. For a great driving detour, continue up the valley road beyond the hatchery, where you may encounter an Amish horse and buggy.

Back on Highway 16, the route climbs to the bluff tops and then mostly stays on the farmland plateau to Preston. Watch along the forested edges of the fields for deer and wild turkeys. Camp Creek, east of Preston, is a popular trout stream and a pleasant paved path follows its course. The town boasts the 1869 Fillmore County Jail. In the fall, seek out locally grown apples.

Southwest of Preston is Forestville/Mystery Cave State Park, with a unique mixture of attractions. The park was established in 1963 and preserves the pioneer-town site of Forestville, which existed from 1853 to 1910. When Forestville was bypassed by the railroad in 1868, the community began to dwindle. By 1890, Thomas Meighen, the son of a Forestville founder, owned the entire town. About fifty people lived

The historic village of Forestville is preserved in a state park of the same name, which is popular with horseback riders and trout anglers.

there and worked for him. The park re-creates 1899 with costumed actors in a restored village that includes a store and a post office, the Meighen residence, and farm buildings. Other historic sites, including the Zumbro Hill cemetery, are marked with signs. The south fork of the Root River and its tributaries, Forestville Creek and Canville Creek, pass through the park. All three are excellent trout streams.

Forestville is an excellent place to observe bats. In the evening, you'll see little brown bats fluttering around the Forestville town site, where they roost in outbuildings. About two thousand bats winter in Mystery Cave. With more than twelve miles of passages, Mystery Cave is the longest cave known in Minnesota. The cave contains stalagmites, stalactites, and underground pools. If you take a tour, bring a sweater, because the underground temperature is a constant forty-eight degrees.

False rue anemone is one of the wildflowers growing in the shaded valleys of Beaver Creek Valley State Park.

The Amish people in southeastern Minnesota still use horse-drawn buggies for transportation.

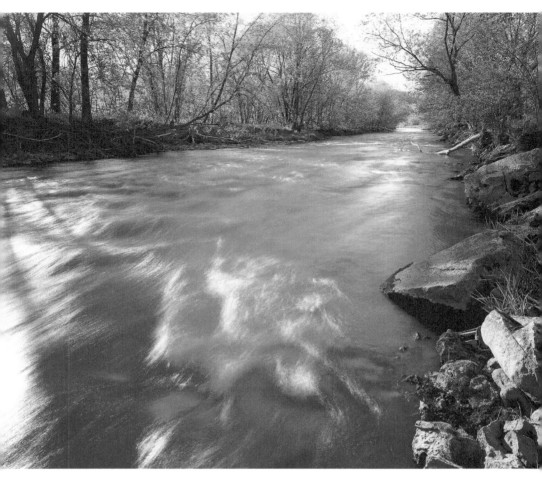

A popular trout stream, the Root River courses through a fertile valley in the rugged, bluff country landscape.

U.S. Highway 52 south from Preston to Harmony is called the Buggy Byway. On a nice day, you are very likely to encounter Amish families traveling in horse-drawn buggies. Tours of nearby Amish farms and Amish crafts are available. If you visit the Amish, treat them with respect: Ask for permission before taking photographs; slow down when you meet buggies on the road.

Spring Valley, on the western edge of the driftless area, has historic sites, including a Methodist church that is on the National Register of Historic Places.

ROUTE 28

Adrift in the
Driftless Region

HOUSTON AND FILLMORE COUNTIES

||

Directions From Brownsville, go west on County Road 3 to Caledonia. You can go west on Minnesota Highway 44 to Spring Grove, then loop north on County Road 4 to Black Hammer and Yucatan, eventually turning south on Minnesota Highway 76 to return to Caledonia. Take Minnesota Highway 249 east from Caledonia to Freeburg and Reno.

||

Wild trout grace a stream with their presence. They live only where the water is cold and clean. In turn, trout streams grace the landscape. Houston and Fillmore Counties are laced with trout streams. And this is truly a place touched with grace. Forming Minnesota's southeastern corner, the two counties are a wonderland of bluffs and forested valleys. Old red barns and shady farmsteads seem frozen in time. The atmosphere is vaguely southern, no doubt due to the influence of the Mississippi River. At night, you may hear the mournful baying of coonhounds echoing in the woods.

The trout streams splashing through the hollows and valleys are a product of the driftless landscape. The limestone bedrock is porous, fractured, and honeycombed. Water runs through the limestone and leaks to the surface in numerous springs. Coming from underground, the water is an even, cold temperature year-round, creating a nearly perfect environment for trout. When the first settlers arrived in Houston County, the creeks teamed with native brook trout. As land clearing and erosion took their toll on the watersheds, brook trout nearly disappeared. The brown trout, brought from Europe and introduced

In the southeast, forested hillsides are interspersed with farmlands on the valley floor.

to the region in the late 1800s, now predominates. Brown trout can tolerate somewhat warmer water temperatures and lesser water quality than brook trout, which are mostly restricted to headwater creeks. Many streams have naturally reproducing trout populations. Others are stocked with hatchery-reared fish. The smallmouth bass, also native, lives in the larger driftless streams.

Many of Houston and Fillmore Counties backroads follow the trout streams through the valley bottoms. It is easy to find places to go fishing. But a true backroads roamer will find these twisting, narrow roads and the countryside so interesting, that it may be hard to find time to fish. Start your trek going west on County Road 3 from the old river town of Brownsville, and you'll soon reach Caledonia. This town is called Minnesota's Wild Turkey Capital for good reason—turkeys

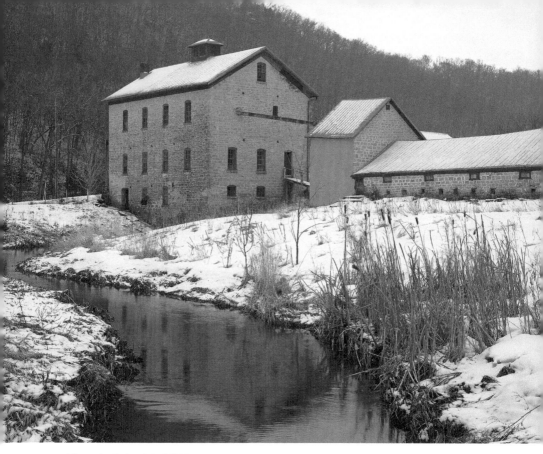

Historic Scheck's Mill is a privately owned water-powered mill located near Beaver Creek Valley State Park. The mill, built in 1876, was constructed with native stone.

abound in the surrounding hill country. Biologists believe that wild turkeys were native here and then extirpated by pioneer settlers. Wild turkeys captured in other states were stocked in southeastern Minnesota decades ago and have flourished. In spring, go out to the forest at daybreak on still mornings and listen for turkeys gobbling from their roosts.

Beaver Creek Valley State Park, west of Caledonia, is a lovely park where you can set up a base camp beside a trout stream to explore the area. The stream is fed by cold springs that percolate from the valley walls. The park contains some uncommon prairie and forest plants. Uncommon songbirds, such as the Acadian flycatcher and Louisiana waterthrush, are attracted to the lush valley habitat. Birders could encounter a timber rattlesnake. The big snakes exist in

low numbers throughout the bluff country and are protected by state law. Wildlife biologists recommend leaving the snake alone if you do happen upon one.

If the park is your base camp, consider forays with Caledonia as a hub. Minnesota Highway 76, from Caledonia south into northeastern Iowa, is a pleasant bluff country byway. Minnesota Highway 44 leads to Spring Grove, Minnesota's first Scandinavian settlement, and you'll find plenty of evidence of the community's ethnic heritage. Look for examples of rosemaling on the water tower and on window boxes in the business district.

Go north from Spring Grove to the tiny rural communities of Black Hammer and Yucatan. Look for the Winnebago Indian Catacombs of Yucatan, and the historic Lutheran Church in Black Hammer that is built upon a mound shaped like a hammer. Tucked away in a valley a few miles farther east is a water-powered mill. If you again come to Caledonia, continue east on Minnesota Highway 249 to Freeburg. This town's St. Nicholas Church was built in 1868 and has a fossil stone cross in the cemetery.

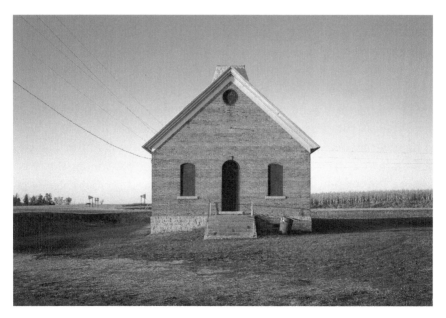

The brick schoolhouse in Black Hammer Township has withstood the test of time.

Rollin' Down the River

RED WING TO THE IOWA BORDER

Directions Follow U.S. Highway 61 south from Red Wing to La Crescent, then Minnesota Highway 26 to the Iowa border.

"The sun shines bright o'er pretty Red Wing," goes the old song, but the truth is that the Mississippi River town is pretty in any weather. In fact, U.S. Highway 61 from here south to the Iowa border is among Minnesota's most scenic drives. Here the Mississippi, bolstered with the flows of the Minnesota and St. Croix, changes in character from a young, headwaters stream into Old Man River. In places, the river is over a mile wide. Running broad and strong through a valley sculpted with high bluffs, this is a river that supports not only the traffic and commerce of powerboats and barges in the main channel, but also floods a secret, bottomland world of sloughs, backwaters, and side channels.

Minnesota is a long way north of Hannibal, Missouri, but this is nevertheless the Mississippi River of Mark Twain. On the side streets of the river towns, you wouldn't be surprised to encounter Tom Sawyer painting a fence. Huck Finn and Jim could camp and fish among the river islands. But Twain's Mississippi has changed. The U.S. Army Corps of Engineers built a series of locks and dams along the river and dredged a channel to accommodate barge traffic. These human manipulations fundamentally altered the character of the river, slowing the currents and creating pools in the bottomlands. The natural rhythm of the river rising during spring floods, with water levels dropping during summer and fall, is now controlled to meet the needs of navigation.

Still, the river remains a wild place. Slide a flat-bottomed boat into a backwater slough and you enter a world inhabited by a diverse array

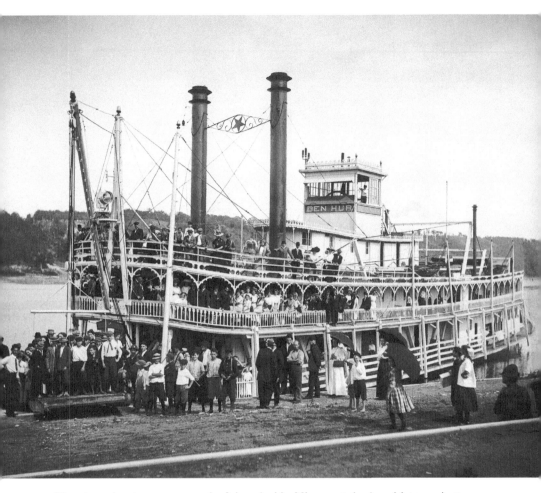

The steamboat era was a colorful period in Minnesota's river history. Just as the steamer *Ben Hur* made excursions from Red Wing to Stillwater in 1911, boats still ferry tourists along the storied Mississippi River. *Courtesy of the Minnesota Historical Society*

of fish and wildlife. The importance of this river habitat was recognized in the 1920s by Will Dilg, one of the founders of the Izaak Walton League of America, who successfully had the river protected as the Upper Mississippi National Wildlife Refuge. Today we enjoy Dilg's legacy. In winter and spring, bald eagles gather near ice-free areas to feast on fish, attracting thousands of birders to places like Reads Landing, where you can watch the majestic birds—often just a stone's throw

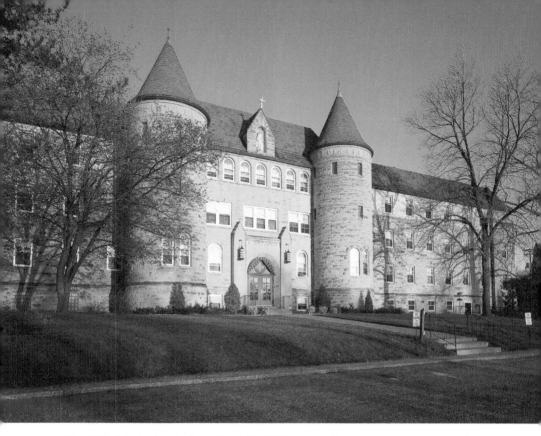

The Villa Maria, located south of Red Wing near Frontenac, was operated as a boarding school for girls from 1891 to 1969. Still run by the Ursuline Sisters, the facility is now an ecumenical retreat center.

away. Huge flocks of tundra swans and canvasback ducks stage on the river during their spring and fall migration flights. In summer, you'll see dozens of turtles sunning on logs in backwater sloughs. There is even a remnant population of small missauga rattlesnakes living in the river bottoms and a few timber rattlers in the hills.

Of course, the river has a rich human history, too. It is popular with boaters, including a free-spirited few who live like vagabonds in houseboats and other craft. You may even see a paddleboat, hearkening to the era of Mark Twain, plying the channel or docked in a river town. Once the primary form of river transportation, today the historic boats haul tourists. Those who prefer to keep their feet on dry land will find plenty of places to get near the water's edge. You can even watch boats pass though some of the locks.

LEFT AND BELOW: Nineteenth-century Winona displayed its prosperity in the elegant architecture of its business district—architecture that incorporated an outstanding collection of stained glass. It decorates several buildings in the downtown area, including the J. R. Watkins Company Administration Building and Merchants National Bank.

The river towns are like no others in Minnesota. Although time hasn't stood still along the Mississippi, it has certainly slowed down. Some of the architecture dates to the mid 1800s. The historic main streets of Red Wing, Wabasha, and Winona are lined with stately, red brick buildings built at a time when America was still a place of small towns. Along side streets shaded by huge hardwoods you'll find the sort of neighborhoods where folks once had iron deer for decorations in their front yards and all the kids waited for the daily arrival of the

ice cream man. Down by the river, you can find a more ramshackle slice of life, the places once frequented by river men. Indeed, you may meet their descendants in a crusty bait shop or quiet saloon. For those who prefer a more genteel history lesson, there are renovated hotels, restaurants, and bed and breakfasts.

On U.S. Highway 61, you can set your cruise control and enjoy the passing views, but to really soak in the atmosphere it is best to take your time and explore. In Lake City, walk the pier jutting into Lake Pepin, a natural wide spot in the Mississippi. This town proclaims itself the birthplace of water-skiing. If you have the time, venture across the river to Wisconsin where Maiden Rock offers a terrific view of the Mississippi. Back in Minnesota, below Lake City, the highway follows close to the shore of Lake Pepin.

At Reads Landing, the river narrows again. South of Wabasha, at Kellogg, venture toward the river along County Road 84 that leads among the dunes at Kellogg-Weaver Dunes Scientific and Natural Area and the McCarthy Lake Wildlife Management Area. These areas contain a mixture of sand prairie and bottomland habitat. Notable are the desert-like sand dunes, which support unique plant communities. If you are here in the summer, please yield to all turtles. The rare Blanding's turtles travel overland to lay their eggs in the dunes. Both adult and newly hatched turtles are vulnerable to vehicles when they cross the roads. The Zumbro River's dead channel, blocked by a dike at Wabasha, twists through the bottoms and marshes of McCarthy Lake. Although bordered by U.S. 61, the dense, flooded cover at the wildlife area is inaccessible to all but the most determined wildlife enthusiasts.

At Weaver, the Whitewater River enters the Mississippi in the Weaver Bottoms, part of the Upper Mississippi River National Wildlife and Fish Refuge that extends 261 miles south to Illinois. Weaver Bottoms is a prime place to look for waterfowl.

You can drive to the top of the bluffs in Winona for a view of a river town that was once a steamboat stop. The Julius C. Wilkie Steamboat Center is here. Just south of Winona, a valley side road leads to Pickwick, where a historic mill, made of native limestone, sits beside a shady creek. Another worthy detour, especially in spring, is the Hiawatha Valley Apple Blossom Drive near La Crescent, the town where U.S. 61 heads across the river to Wisconsin.

In 1870, horse-drawn wagons and buggies made up the traffic on Red Wing's Main Street. *Courtesy of the Minnesota Historical Society*

PAGES 236-237: The Weaver Dunes Scientific and Natural Area offers an excellent opportunity to explore the ecologically diverse Mississippi River bottoms.

From La Crescent to the Iowa border, Minnesota Highway 26 continues along the Mississippi. This is a road less traveled, leading to the state's very southeastern corner. If Minnesota has a banana belt, it is here in Houston County. Winters here are comparatively mild, allowing trees such as black walnut and hickory to flourish. The river bottoms below Reno resemble the bayous of the Deep South. From here, the Mississippi's headwaters at Lake Itasca seem a long way away.

THE RIVER PARKS

THREE STATE PARKS along the Mississippi offer history, bluff-top views, and opportunities to get up close and personal with the river ecosystem.

Humans have lived along the river's edge for a long time. At Frontenac State Park, French Jesuit missionaries had a stockade on Lake Pepin from 1727–36. But they weren't the first ones here. Archaeologists have uncovered native camps, mounds, and burials dating to before the time of Christ. In the latter half of the nineteenth century, Frontenac blossomed as a resort town, only to wither when river traffic dwindled. Now it is a state park, where hiking trails lead to overlooks from bluffs 450 feet above Lake Pepin.

Great views are also available at Great River Bluffs State Park. Once known as O. L. Kipp State Park, this park is located on the west side of U.S. Highway 61 between Winona and La Crescent. It is an excellent place to experience the hardwood forests and steep terrain of the bluff country. There are ancient native mounds here, too.

South of Minneiska, John A. Latsch State Park protects Faith, Hope, and Charity, three dramatic bluffs just upstream from Lock and Dam 5. A hiking trail leads to their summits.

Great River Bluffs State Park overlooks the mighty Mississippi. The river and its backwaters form a productive riverine ecosystem.

ROUTE 30

Along the Zumbro

ZUMBROTA TO WABASHA

Directions From Zumbrota, go south on U.S. Highway 52, then follow Minnesota Highway 60 east to Wabasha.

Minnesota has many lakes and streams, but few noteworthy bridges. Aside from the Aerial Lift Bridge in Duluth, few other spans across the water are especially photogenic or significant as landmarks. An exception is the Zumbrota Covered Bridge. Although covered bridges were common enough in Iowa that someone wrote a book about those in Madison County, they generally are not associated with the Minnesota landscape. The Zumbrota Covered Bridge crossed the Zumbro River until 1922, when its value as a historical exhibit exceeded its transportation function. Today the bridge is the centerpiece of a town park.

Zumbrota is a good place to begin a backroad meander down the Zumbro River to its confluence with the Mississippi at Wabasha. The Zumbro is formed by several tributaries that come together at, or downstream of, Mazeppa. The south fork of the Zumbro passes through Rochester and is impounded at Silver Lake before flowing north to join the main stem. The Zumbro River is a classic bluff country stream. You can get to know it from an inner tube. Spend a summer afternoon floating a stretch of the stream, which splashes through butt-bumping riffles to lazy pools. The riverbanks are a wild hardwood forest interspersed with occasional bluffs. A float from one bridge to another, several miles downstream, takes a few hours. If you'd rather have a dry butt, drift the river with a canoe and cast for smallmouth bass.

At Frontenac State Park, a short hike to the bluff tops provides outstanding views of the Upper Mississippi River Fish and Wildlife Refuge.

Minnesota Highway 60 follows the Zumbro Valley downstream from U.S. Highway 52 (the main route between the Twin Cities and Rochester) to Wabasha. The highway is a scenic thoroughfare, coursing through the ridges and rills along the river's carved, limestone corridor. At times it is near the river, elsewhere the road goes overland. Determined sidetrippers can take County Road 68 south, then County Road 11 east for a route that hugs the curves of the Zumbro more closely as it winds through Hammond, Jarrett, and Millville. (County 11 loops back north to join Highway 60 east of West Albany.) South of Dumfries is

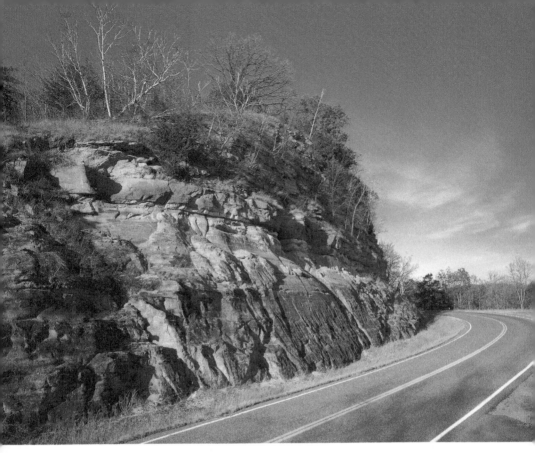

Minnesota Highway 60 winds along limestone bluffs as it drops into the Mississippi River Valley.

extensive state forestland called the Zumbro Bottoms Unit. This area contains a wealth of walking trails through the river's flood plain and is tremendous turtle habitat. Look for turtles sunning on half-submerged logs. With sharp eyes and a good field guide, you may be able to spot and identify snapping, painted, mud, spiny, or softshell turtles. The uncommon wood turtle also can be seen here. Most likely, you'll encounter this turtle in the bottomland forest rather than along the water's edge.

Winding across the limestone bluffs above Wabasha is a dramatic drive. Take advantage of the roadside pull-offs to enjoy the spectacular views of the lower Zumbro and Mississippi River valleys. Wabasha lies in the Mississippi River flats and is diked to protect it from floods. The Zumbro River was channeled from its original bed to control the flow.

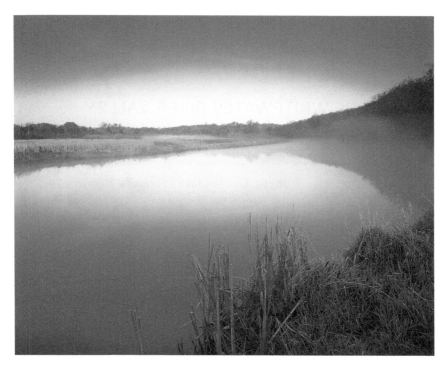

Surprisingly wild, the Zumbro River is a favorite canoe route.

Minnesota's only covered bridge has been restored and now serves as a walk-in entrance to a Zumbrota city park.

Remnants of the steamboat era remain. Wabasha claims the oldest hotel in Minnesota, which was built in 1856 to serve riverboat travelers. The downtown district has a number of fine, old buildings. Go down along the river to see the boats of today's travelers—sleek powerboats that are a far cry from the river's steam-powered past.

ROUTE **31**

Down in the Valley

THE WHITEWATER RIVER VALLEY

Directions — From St. Charles, take Minnesota Highway 74 north to Weaver, then follow County Road 26 west.

Oh, to be a turkey vulture. Imagine what it must be like to lift off from a hillside pine and float over the Whitewater River Valley. Beneath you is an expanse of rugged, hardwood forest and streams of cold, clean water. Near the high, limestone bluffs that border the valley, you can catch a thermal and soar higher, above the ridges, to drift silently over a broad plateau of verdant farmland. Even a buzzard must be awed by the beauty of this place.

The Whitewater River Valley is a paradise of public land. Driving north from St. Charles on Minnesota Highway 74, the public holdings start as you first descend into the valley and continue all the way to the highway's junction with U.S. 61 at the Mississippi River. Whitewater State Park and the expansive Whitewater Wildlife Management Area are models of natural resource management and conservation. They are also positive proof that, with time, nature can fix what humans have broken.

The Whitewater Valley has an unfortunate history. Settlers found a valley of wondrous fertility when they arrived in the 1850s. Hoping to convert forests to farm fields, they and their descendants cut down trees in the bottoms and along the slopes, then broke the ground with a plow. For several decades they continued to clear and farm more land, both in the valley and up on the plateau where the Whitewater's three branches began. The original forest and prairie had controlled and buffered runoff. Without them, water running across hillside

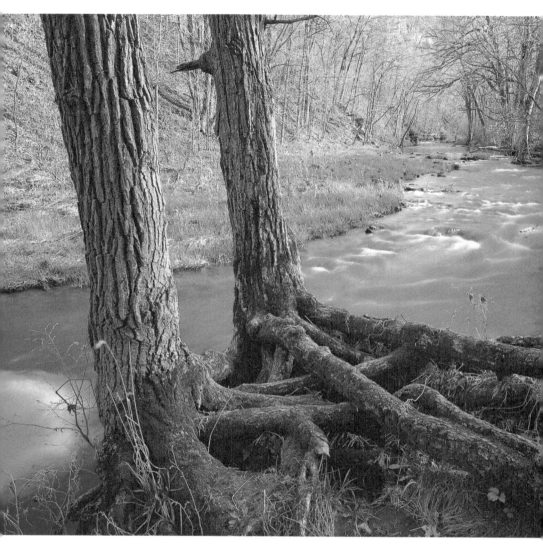

Constant flooding of the Whitewater River led to conservation efforts to restore the valley's forests and create a public recreation area.

crop fields cut gullies and carried topsoil downstream. By 1900, the watershed's natural hydrology was so altered that a river that once ran clear and kept to its banks became prone to ugly, muddy floods that buried the bottomlands with silt. In 1938, the Whitewater overflowed its banks twenty-eight times. Valley communities of Beaver, Fairwater, and Whitewater Falls withered as the floods and silt smothered the

A mile-and-a-half hike is required to reach the Nicholas Marnach House, built by stonemasons from Luxembourg in the 1850s.

bottoms. Some homes and buildings were slowly buried with sands deposited by the raging water.

Protection of the Whitewater Valley began with the creation of the state park in 1919, but it wasn't until the 1940s and 1950s, when Richard Dorer worked for the state conservation department, that restoration truly began. Dorer was a visionary conservationist who led efforts to stop erosion and flooding in the Whitewater Valley and develop it as a public natural area. The state acquired eroded lands and repaired damage so plants could take root. Vegetation was established on bare hillsides. The lower Whitewater was diked into wildlife pools to ease flooding. Stream banks were stabilized and habitat improved for trout. Above the valley bluffs, soil conservation practices were put into place to lessen erosion and runoff from the fields. Today the Whitewater River is a healthy trout stream and the wooded hillsides and bottoms support an abundance of wildlife.

The visitor center at Whitewater State Park is the first stop on a backroad drive through the valley. The park is located on the middle

fork of the Whitewater, a popular trout stream, and the visitor center has a live trout display. Park trails vary in difficulty, but a walk along a shady trout stream or above on the bluffs presents the natural world at its best. A series of hiking trails leads to bluff tops. Inspiration Point, Eagle Point, and Signal Point offer impressive views of the Whitewater Valley. Be prepared to huff and puff, because the bluffs are two hundred feet above the valley bottoms. Along the steep ridge slopes, you'll find open, grassy areas called goat prairies, so named because only someone with the sure-footedness of a goat can negotiate them. These dry prairies support a distinct ecosystem that includes grassland vegetation and animals such as ring-necked snakes.

Downstream from the park is a tiny community called Elba, where the Whitewater's three forks join. The Elba Fire Tower is a local landmark. Consider detours on County Road 26—south to the Crystal Springs State Trout Hatchery or north to petite Carley State Park.

Back on Highway 74, just west of the Whitewater Wildlife Management Area headquarters is the parking lot for the Marnach House trail. Dating to 1857, the home was built by a pair of stonemasons from Luxembourg. Now restored through the efforts of modern-day craftsmen from Luxembourg, the home lies at the end of the one-and-a-half-mile trail.

Another historic site is the Beaver Cemetery, a short distance west of Highway 74 on County Road 30. Dating to the 1850s, Beaver was one of the valley's oldest settlements, but the town was eventually buried ten to fifteen feet beneath flood sediments eighty years later. Located above the valley floor on a hillside terrace, the cemetery contains the graves of early settlers. The champion of the Whitewater Valley, Richard Dorer, is buried here.

As you drive through the lower Whitewater Valley, watch for wildlife. White-tailed deer and wild turkeys are abundant. Expect to see Canada geese, mallards, and other waterfowl in roadside pools. Sighting sandhill cranes or otters is possible. The valley broadens as you near the Mississippi. At Weaver, follow County Road 26 west for about one mile to the overlook on the bluffs. From here you can see the lower Whitewater River, the Weaver Bottoms, and the distant ridges on the Wisconsin shore. If you see a black bird soaring on the thermals, take a closer look. It may be an awestruck turkey vulture.

INDEX

ABOUT THE AUTHOR
AND PHOTOGRAPHER

Shawn Perich

Shawn Perich is a writer who lives on the North Shore of Lake Superior. He authors a popular weekly column in *Minnesota Outdoor News* and writes about conservation and the outdoors for national and regional publications. Perich is the author of several books, including *The North Shore, A Four-Season Guide*, published in 1992. He is the co-owner of Northern Wilds Media in Grand Marais, which publishes *Northern Wilds* and *North Shore Highway 61*. When he isn't writing, Perich spends his time fishing, hunting, and roaming the northwoods with his companion Vikki and their two dogs.

Gary Alan Nelson

Gary Alan Nelson of Lindstrom, Minnesota, is a full-time photographer specializing in large-format natural history and rural American photography. His images have been published by the Audubon Society, *Backpacker*, Brown Trout, *Country*, Hallmark, National Geographic publications, The Nature Conservancy, *Outdoor Photographer*, *Outside*, *Reader's Digest*, the Sierra Club, the Wilderness Society, and Voyageur Press. His images are also sold as fine art photographic prints and can be viewed at www.garyalannelson.com.

Courtesy of Breanna Super

Courtesy of Gary Alan Nelson

CPSIA information can be obtained at www.ICGtesting.com
Printed in the USA
LVOW01s1609150515

438614LV00008B/9/P